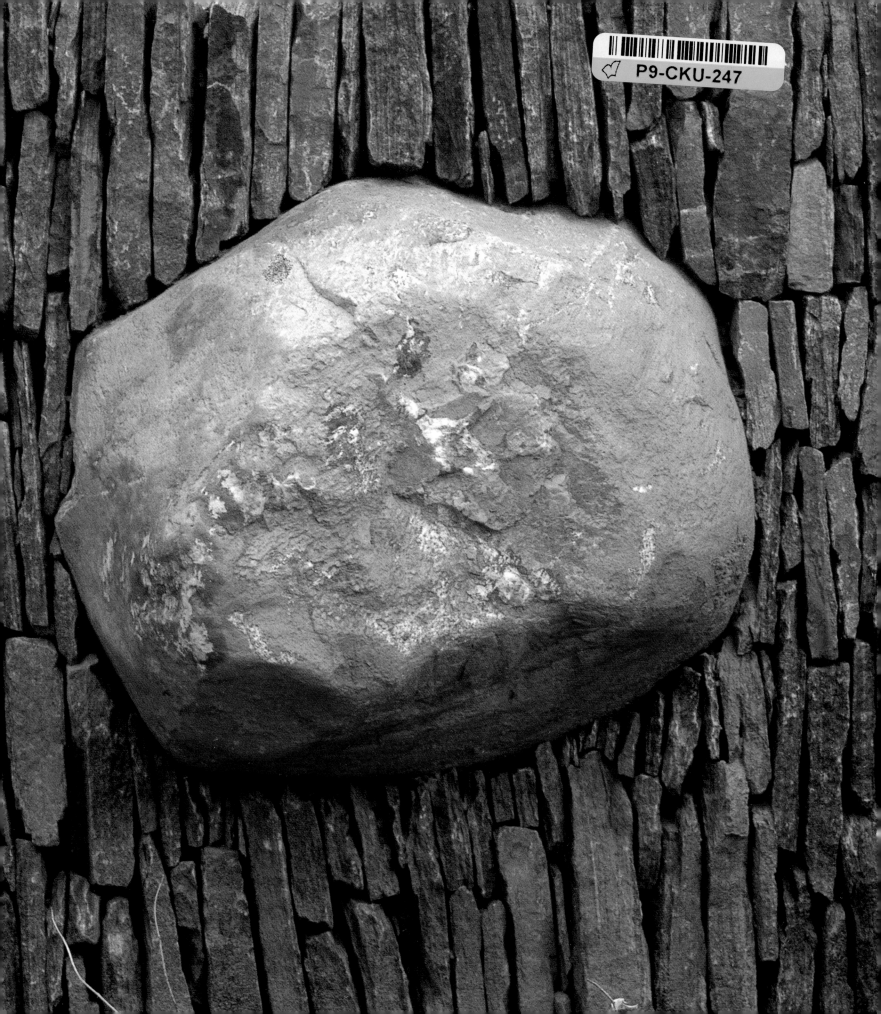

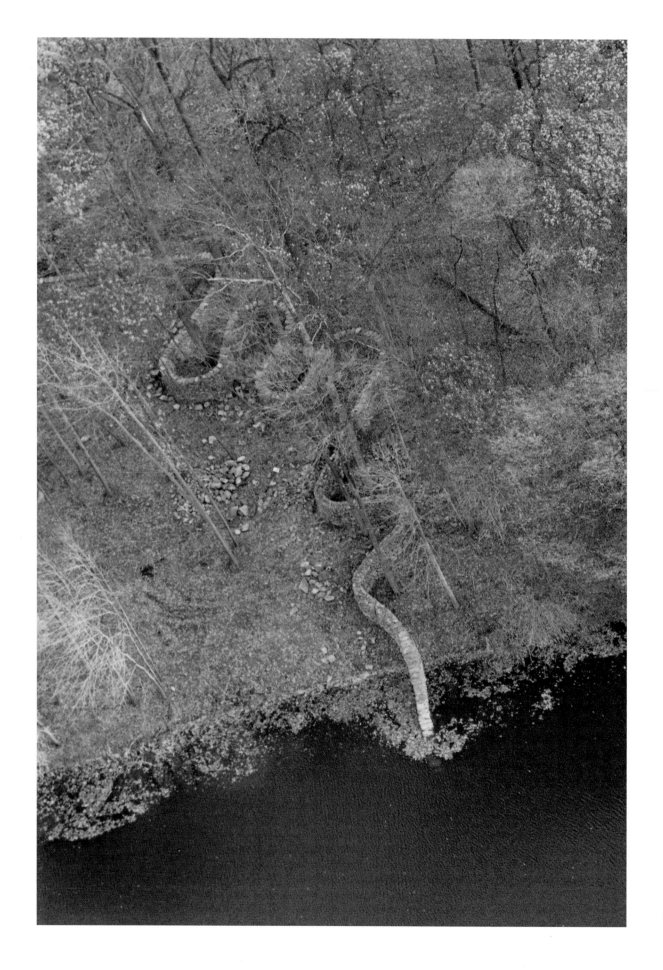

For
Joel
and
Sherry

WALL

AT STORM KING

Andy Goldsworthy

Essay by Kenneth Baker

Photographs: Andy Goldsworthy and Jerry L. Thompson

Harry N. Abrams, Inc., Publishers

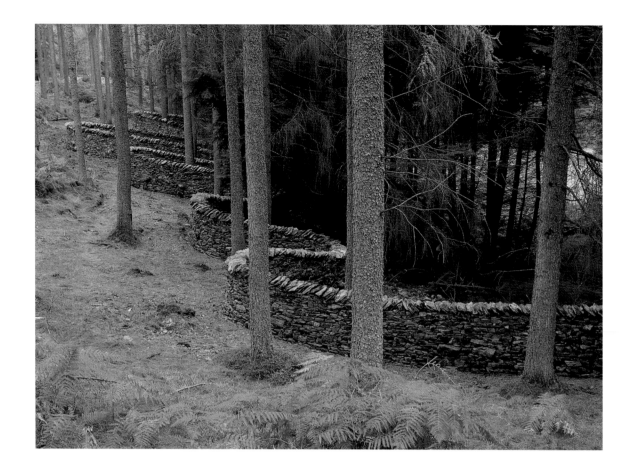

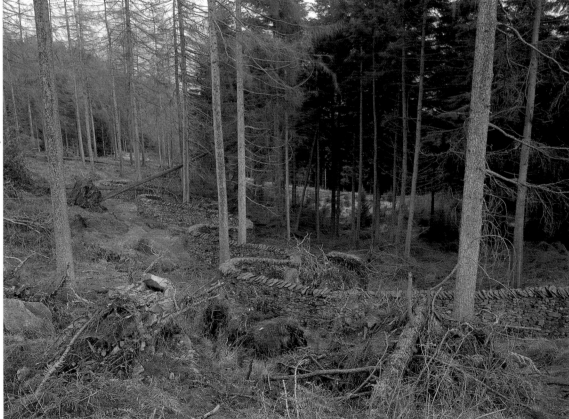

WALL

The wall walks the fell –
Grey millipede on slow
Stone hooves;
Its slack back hollowed
At gulleys and grooves,
Or shouldering over
Old boulders
Too big to be rolled away.
Fallen fragments
Of the high crags
Crawl in the walk of the wall

A dry-stone wall
Is a wall and a wall,
Leaning together
(Cumberland-and-Westmorland
Champion wrestlers),
Greening and weathering,
Flank by flank,
With filling of rubble
Between the two –
A double-rank
Stone dyke:
Flags and through-
stones jutting out sideways,
Like the steps of a stile.

A wall walks slowly.
At each give of the ground,
Each creak of the rock's ribs,
It puts its foot gingerly,
Arches its hog-holes,
Lets cobble and knee-joint
Settle and grip.
As the slipping fellside
Erodes and drifts,
The wall shifts with it,
Is always on the move.

They built a wall slowly,
A day a week;
Built it to stand,
But not stand still.
They built a wall to walk.

Norman Nicholson

GRIZEDALE/STORM KING

The wall at Storm King wall has an earlier partner in the north of England in Grizedale Forest, Cumbria, where I first took a wall for a journey around trees. The original walls in both places were redundant and had become derelict. Grizedale used to be farmland but was then crop-planted with trees, whereas at Storm King, the trees have simply regenerated of their own accord. The old wall at Grizedale had been knocked down in the process of tree-planting, but the line it had followed was still visible. I remade the wall – no longer straight, but meandering through the trees – and it became known locally as 'the wall that went for a walk', derived from 'Wall' by the Cumbrian poet Norman Nicholson.

After completing the wall at Storm King, I revisited Grizedale Forest. There had been big storms and the wall there had been badly damaged by fallen trees. Over the last few years the site has changed substantially, including the felling of trees, which has opened up the area. The work had been losing its edge for some time, but this collapse seems to have given it new energy. After remaking the wall at Storm King, it was beautiful to see the Grizedale wall so derelict – as though its spirit had lifted up and gone to the new wall.

Opposite
Grizedale Wall

CUMBRIA
1990 & 1997

Overleaf
Grizedale Wall

CUMBRIA
1997

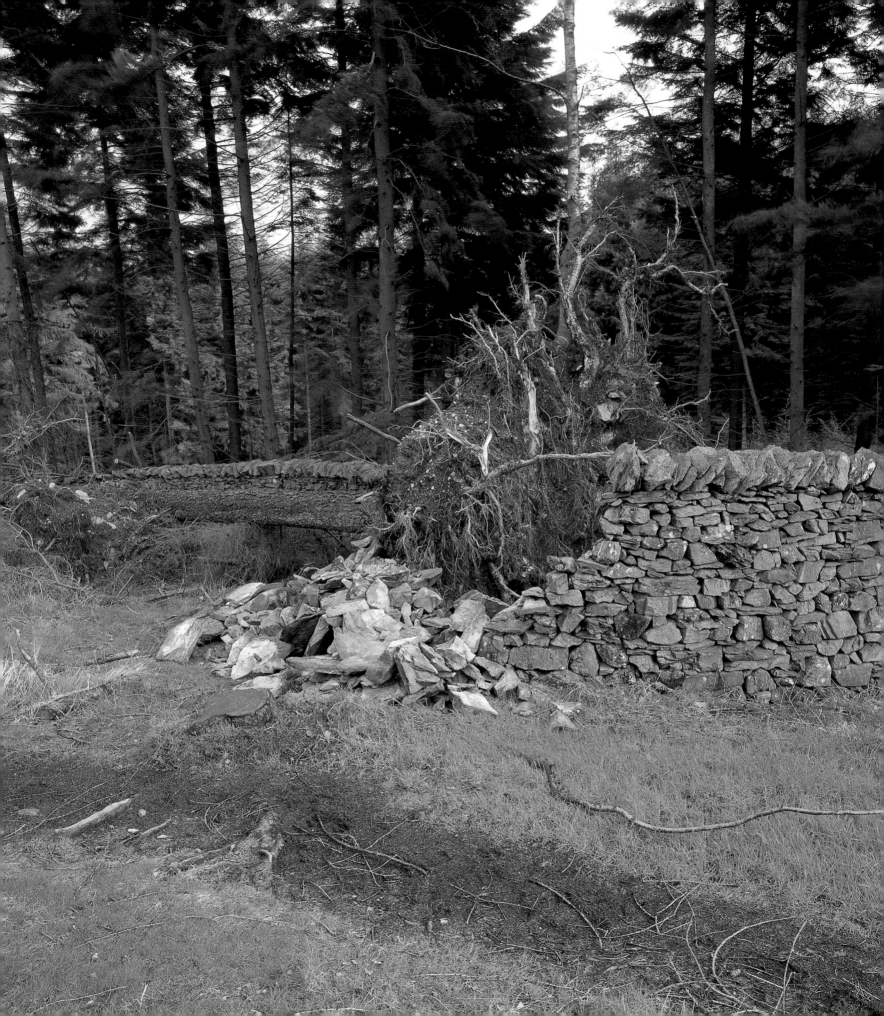

INTRODUCTION

Kenneth Baker

New England stone walls ran through my childhood. Half a century ago my family's house was at the outermost fringe of Boston's suburban sprawl, and from my room I could look down through tall backyard oak trees and see, well beyond the property line, the shambles of a dry-stone wall. Countless times I followed that wall due south, skirting the next – and last – lot on our street, into woods deep enough to cut off all sight and sound of the surrounding neighborhoods. As I walked its course through a great mulch of rotting leaves, broken branches and fallen trees, the one tumbledown wall intersected others, even more dilapidated.

As a boy I imagined the walls to be property lines of near-prehistoric antiquity, never guessing that not the walls but the woods were the best index of passing time. That walls ran through woods meant that the land had once been cleared for farming and the trees long since allowed to grow back. Envisioning their builders working their way along opposite sides, as Robert Frost describes in the famous poem 'Mending Wall', I saw the walls as archaic markers of wary Yankee cooperation and agreement to differ. I was too innocent to guess that they might have been battle lines in a conflict of neighbors raising livestock and those growing crops or, more fatefully, of native American and British colonial lifeways. Nor could I see the walls then as figures for the limits of selfhood or sensibility, as Frost did when he wrote wryly of his suspicious neighbor across such as wall, 'He is all pine and I am apple orchard./ My apple trees will never get across/ And eat the cones under his pines . . .'

To me the walls were trails to take me temporarily out of the self that I felt school, home and my own fears imposing on me. My only correct intuition about the ruined walls was that they led back in time as well as forward in space. What mattered most to me then was that, as sunset approached, the wall I had followed out into the dangerous freedom of woodland reverie would lead back to the confining, consoling certainties of family life.

These memories returned as I probed for the roots of the long, meandering wall that Andy Goldsworthy built at Storm King Art Center. The south edge of Storm King's vast

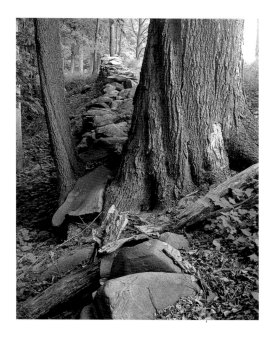

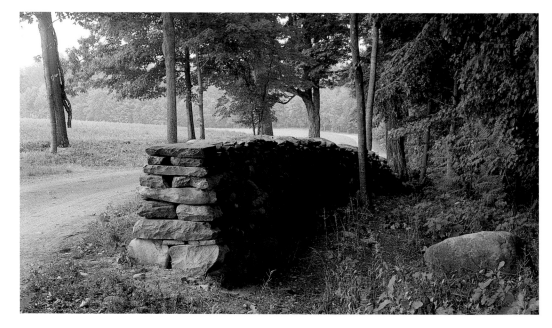

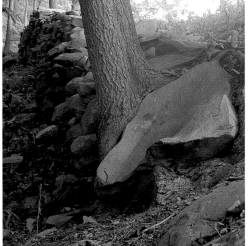

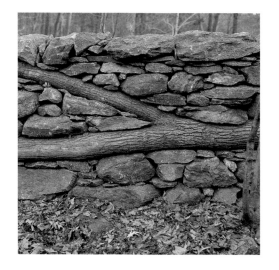

sculpture park is much like the landscape where I grew up, except that here maples, not oaks, predominate. In fall, their leaves turn a brilliant yellow that seems to make sunlight palpable. Goldsworthy played upon that impression in an ephemeral work he made at Storm King, pressing yellow leaves into the bark grooves of a large tree trunk, as if incident sunlight had lodged there (see page 37).

Approach it across the hilly field quartered by Richard Serra's steel-plate 'Shunnemunk Fork' (1990), and Goldsworthy's Storm King wall appears to rise, at its east end, from behind a forested ridge. Once at the ridge, you can see that the sculpture springs from an old, derelict wall, as dishevelled as if the slope had pulled the ground from under it. The ruin is hard to make out, trailing away through the trees; here it is a foot or more high, there a mere scatter of stones, half buried.

Finding what Goldsworthy considers the source of his piece involves side-stepping gingerly a few yards down the slope to where a fat stone from the old, broken wall has nestled itself into the trunk of a sizeable tree. In fact, the opposite is probably more true: the tree has accommodated itself to the stone. Their slow interaction – tree molding itself to stone, stone giving ground year by year, millimeter by millimeter – is the signature of Goldsworthy's thinking about the Storm King wall.

The same theme is sounded very differently in another wall Goldsworthy built for private collectors in nearby Westchester County, New York. There the wall, in woods far behind the house, incorporates the forked branch (or trunk) of a fallen tree. So well executed is its construction that this improbable sight gives the impression of a bizarre chance occurrence. The wall is destined to collapse as the wood rots, reversing the more common pattern wherein trees undermine standing walls when allowed to grow back on land formerly farmed.

Goldsworthy's Storm King wall rises from its source straightforwardly enough, but soon swerves to one side, then abruptly switches back, then veers again, again and again, snaking downhill, out of sight. Each curve encloses a tree, or walls it off, depending on one's

standpoint. From the adjacent open field, when the trees are in full leaf, the wall's curves, nosing into the daylight, look like ruined fortifications or castle turrets.

Sighting down along the wall, it is hard to decide whether an enfolded tree is on the same side or the opposite side as yourself. As the curves tighten, the eye accelerates and the wall seems to shake off its own sidedness, as if it could outrun the laws of topology. This impression of acceleration meant intensified labor for the wallers – the dry-stone wall builders – whom Goldsworthy brought over from England and Scotland to help him make the Storm King sculpture. The more circuitous the wall's path, the more time-consuming was their work.

The Storm King wall's serpentine form is rich in associations, some intended by Goldsworthy, some not. Being unable to discern on which side of the wall a tree stands has peculiar echoes for the American viewer. They reverberate, for example, in the refrain of an old labor anthem: 'Which side are you on?' Americans feel it a matter of civic duty to take sides – at least in inwardly – on any issue of social or moral import. (That may be one implication of the famous line Frost ascribes to his taciturn counterpart: 'Good fences make good neighbors': that is, the willingness to take a stand, rather than the position taken, is the true basis of reciprocal respect.) Though it may be a Pyrrhic exercise, this cultural reflex transmits faint collective memories of dissensions that have imprinted the American psyche. The most catastrophic, of course, was the Civil War. Its divisions are still felt in the uneasiness of race relations and in the strange friction between North and South that has been redefined in recent years as a 'culture war' between secular humanists and Christian fundamentalists. Since the 1960s, popular consciousness of the civil rights cause has diffused into disputes about immigration and, latterly, modern guilt over the European colonists' extirpation of native peoples. As bizarre as such concerns appear to observers elsewhere in the world, they can stir vehement responses in the American soul.

Goldsworthy may know little or nothing of these particulars, but he told me 'I am mindful of the darker side of walls because [America] is where people came when they were displaced from what had been common land by the Enclosure Acts in Britain.' In any case, a sculptor's feeling for place has apparently led him to make several walls in America that induce the confusion – both comic and painful – as to which side of them one is on. Walking the Storm King meander, or the other, even more extravagantly looped wall on nearby private land, one can suddenly have the illusion of being unaccountably on the opposite side of the wall. This may be a British land artist's intuitive translation of a basic American dilemma: with the freedom to take any position comes the anxiety of not knowing where one really does stand.

'We don't have that pioneering aspect you still have a residue of in America,' Goldsworthy remarked to me. 'Everywhere you walk in Britain someone has walked before you, so I don't feel this American need to be the first person to walk somewhere.' The American compulsion to take a stand on every issue of possible social import may be a cultural echo of the mythic pioneering urge to open and lay claim to 'new' territory. 'I don't think my art would have been the same if I'd been American,' Goldsworthy said. 'I don't have this tendency to push the work into division and conflict [that can be identified in American land art]. In Britain, there are public rights of way everywhere, so every town and village has access to the immediate landscape. But there is a strong sense of property

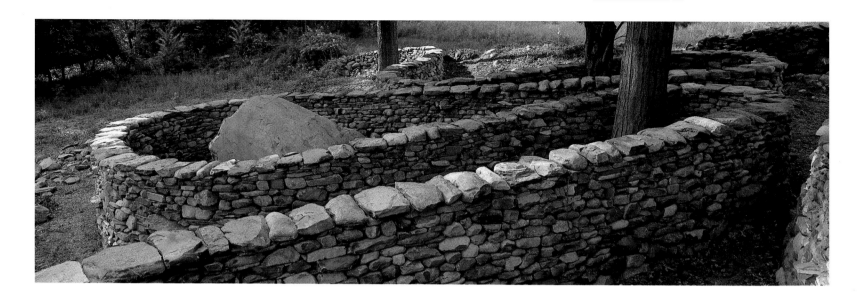

Section of Folded Wall, Orange County,
New York, 1999.

in America. It's hard working here because I'm trying to make things that flow through these limits.'

Setting the course of the Storm King wall was less difficult than determining its height, Goldsworthy explained. 'The higher the wall, the more intimate the space is when you're near the trees. There was some pressure to make it taller so that people wouldn't walk on it. That's a big difference between American and British responses to walls – in Britain we do not walk on walls. I wouldn't like to have to cement the top stones on, but it might be necessary. The vulnerability of the wall is very important to me,' Goldsworthy said, 'because it is true to the vulnerability of the farmers who first partitioned the land.'

On the other hand, he remarked that 'America is a much easier place to work in terms of public response than Britain . . . The number of people who come by and say they're sculptors, or their wives are sculptors, is amazing to me. Being a sculptor in Britain brings up a wealth of antagonism which you don't get in America. You can do what you want here. Whereas you have to earn the right to it where I come from. Actually I find the resistance of the British public very healthy for me. People in Britain are very forceful in their opinions, and they understand a lot of the history I'm trying to connect with.'

People who know the history of old American dry-stone walls can recognize them as relics of European conquest, as Susan Allport explains in her fine book on the walls of the northeast, *Sermons in Stone*. 'Unlike the colonial way of life, which revolved around improvement and required permanent settlements, property boundaries, and such features as fences, buildings and fields that were to be utilized year after year,' Allport writes, 'the Indian way of life was much more mobile. The Indians . . . had learned to exploit the seasonal diversity of their environment – spring's fish spawnings, summer's abundance of fruit and forage plants, fall's exceptional hunting. And instead of permanence, this way of life involved a certain transience – transient corn fields, which were to be abandoned once they lost their fertility, transient villages and hunting and fishing camps . . . It also required a commitment to . . . owning little that could not be carried on their backs. The colonists could not understand why the Indians lived like paupers in a land of plenty because they could not comprehend this more peripatetic way of life.' Fences – and after deforestation

led to lumber shortages, dry-stone walls – were monuments to the Europeans' insistence on permanent settlements and private property. 'Ultimately,' writes Allport, 'Indians were forced to adopt the European method of protecting crops from livestock . . . even though they had no livestock of their own and even though fences were fundamentally antagonistic to their way of life. It was only a matter of time before these native New Englanders, having lost their territories and their traditional means of survival, would also be erecting fences – and stone walls – for the colonists.'

By a cruel irony, as Allport notes, the farmers of the northeast were later thwarted by their own stone walls when it came to competing with Midwestern farmers, whose open land permitted use of the latest machinery to increase productivity.

In aerial photographs taken when the trees were bare, the Storm King wall looks like a giant snake slithering out of or into the pond at the bottom of the hill. To ancient Indo-European cultures the snake was a symbol of regeneration, associated with the underworld and so with agricultural fertility.

Goldsworthy does not want the form of his wall to be taken for an image, though: 'I am not interested in the symbolic or representational aspects of the snake . . . But I have to admit that when I see snakes, they are the perfect sculptural form – no legs! – and their movement is such a perfect expression of their form. They draw the path they're taking, and I look for the same quality in the sculpture I'm making. There is this form I can't stop making which is really snakelike, but I often think of it as a river. It's the idea of fluidity that is the connection, but I'm not really talking about a river either. It's the movement that interests me.'

The thought of the wall – especially its eastern half – as a flow of stones fits the way it spills into the pond. Countless stones built into the wall owe their lumpy shapes to the burnishing action of river water ages ago. And the idea of stone flowing links the magmatic origins of the land's geology, the glaciers' fragmentation and transport of boulders and people's long history of shepherding loose stones into functional structures.

In the serpentine course it takes, the eastern half of Goldsworthy's Storm King wall seems to dodge the practicality traditional to dry-stone walls in America: they avoid the merely ornamental and seek the shortest path. Only one serpentine American wall is an icon of efficiency; Goldsworthy learned about it after he had started work at Storm King. It is the sinuous brick wall Thomas Jefferson built at the University of Virginia. Its design is a triumph of economy, showing how a sturdy wall can be made only one brick thick. 'There is a tradition in Britain of making serpentine walls – we call them "crinkle-crankle" walls,' Goldsworthy told me. 'But mine is much closer to a drawn line than a designed one.'

Goldsworthy's Storm King wall takes its orientation from the old, vestigial wall from which it springs, but he determined its sinuous course by walking the site repeatedly, feeling his way among the trees. Imagining that process, I thought of Richard Long, a British artist eleven years Goldsworthy's senior. Long began to use walking as a method of making art on the land in the 1960s. For Long, walking was both a performance and a means of marking, as can be seen in the tramped-down grass of 'A Line Made By Walking' (1967), a work that survives as a photograph, taken before the matted grass righted itself.

'I like things that draw themselves,' Goldsworthy acknowledged when I asked him about Long. 'But it was the American land artists [Robert Smithson, Walter De Maria,

Christo] who were shown to us when I was an art student. I got to know Richard Long's work only later.' Walks and walls, tree limbs and vines – and perhaps snakes too – all belong in the category of self-delineating things. Think of a vine or a tree limb as time-lapse photography might capture it. The vine curls and spirals its way forward, seeming not to follow a path, but to open one. The tree limb extends and divides, lengthening itself in more than one direction, as if trying to expand its options for continued growth. Goldsworthy's Westchester wall that incorporates a fallen tree limb might be said to 'draw itself' in a double sense.

Across the lake at Storm King, Goldsworthy's serpentine wall appears to re-emerge. It does not continue under water, but Goldsworthy likes the illusion that it does. 'I've seen walls that go into lakes in Britain,' he said. 'There are whole villages under water in Britain and when we get a drought, which is rare, these villages reappear.'

As if transformed by immersion, the Storm King wall rises smoothly on the west side of the pond to a height of about three feet. It makes an oblique angle and, after a break at the road, runs straight uphill, ending at a high wire fence perhaps 100 feet from the busy New York State Thruway.

'There are no trees in the field across the lake for the wall to respond to and so it is straight,' Goldsworthy writes in his notes on Storm King. 'The wall in the trees wove because of the trees, the wall on the field is straight because of the field. Both are lines that talk about the places in which they are drawn.' The visitor cannot argue with the artist's own matter-of-fact account, but may not be willing to stop at that.

The straight leg of the work prepares us for the straightness of the highway beyond, but not for the speed of its traffic, which seems demented compared to the pace of movement and observation that the sculpture dictates. That contrast may cause us to wonder in which direction we are to read the Storm King wall. 'The way you read a sculpture is often primed by the way you approach it,' Goldsworthy acknowledges.

From west to east, the Storm King wall translates the hurried, straight-ahead, pragmatic spirit of the highway into a meander. Read in the opposite direction, it leads from a walk to a race.

From east to west, springing from a ruin, the work seems to go from past to present (or future). From west to east, we can see it two ways: either going from present to past, toward nostalgia or antiquarian curiosity, or from present to future, toward alternative ways of living informed by historical insight. But as Goldsworthy says, 'it's the movement that interests me,' helping us, that is, to see the current disposition of the land – and the life lived on it – as the snapshot of a never-ending process.

'The nostalgic view of walls is a very American view, because most of them have disappeared here,' Goldsworthy commented when I asked him about the temporal orientation of the Storm King wall. 'I still see walls as a vigorous and growing part of the landscape. I bring wallers with me from England and Scotland whose idea of a wall is work, and the idea of work is very important because it makes a strong link to agriculture.' Wallers in the north of England and Scotland typically are sheep farmers who – capitalizing on necessity – develop a knack and reputation for wall building and repair.

Goldsworthy himself has done farm labor and told me that he views farming as 'a very sculptural activity. The making of haystacks is one of the biggest acts of Minimalism you've

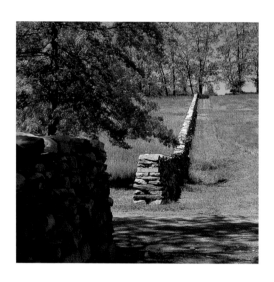

Storm King: first opening in the wall on the western side of the lake.

ever seen. Or planting potatoes – there are the plowed lines on the field and when you plant potatoes you're making an installation. My own thinking is that the Storm King area remained farming land until fairly recently. You're still looking at a farmed landscape here, fields as well as woods.'

The wall works Goldsworthy has done in Britain, especially his vast 'Sheepfolds' project in Cumbria, have involved repairing rundown walls that have never gone out of use. Sheepfolds are traditional dry-stone enclosures that offer sheep shelter from the wind and allow them to be penned when necessary. Many of Goldsworthy's Sheepfolds works are inconspicuous because they involve modifications to stone structures that remain in use, despite the new identity he has given them as works of sculpture.

In America, he notes, 'the walls that are being made or remade now are incredibly severe, geometric, hard walls, which come from a different tradition, closer to gardening. They make very selective use of stone,' whereas in walls that originated in agriculture, 'the stone was used because it was there.' Working in America 'puts me in a slight dilemma,' Goldsworthy told me, 'because walls in Britain need to be continually remade – it's an expression of feeding the wall. But the agricultural wall is dead in America.' Recalling that remark, I wonder whether we might not view the Storm King piece as a colossal incantatory gesture, bringing the wall back to life here, if only under the rubric of sculpture.

'Sculpture can take on the quality of a design in the landscape and I make works that function at that level,' Goldsworthy said. 'But I always feel there's a more profound level of working with the landscape. I'm usually trying to quiet down the aspects that are perceived as being about sculpture. I think the main difference between a design process and a sculptural process is that the latter is close to the way things grow. The large things I make don't arrive large as much American sculpture seems to have. The way my walls are made, stone upon stone, is like growth.'

Hence the impression given by the wall's serpentine form of respecting the trees' precedence: they grew here before it. Besides dramatizing the interplay of wood and stone, this quality echoes the way modern Americans miscontrue antique walls. Finding walls rippling through woodland, we usually assume – as I once did – that they must have marked property lines in a setting where bearings are hard to get or keep. In fact, woodland walls are an index of changing land use. Most old walls were built in a process of deforestation, the necessary clearing of land for farming in times when crops and livestock spelled family and community survival. That trees now engulf a wall says that agriculture ceased there generations ago.

The old mortarless walls that survive in the northeastern United States are made of 'field stone', geological rubble ground into the land by Ice Age glaciers that scraped down to modest scale the region's antedelivuian high mountains. The early European settlers who farmed the land 'thought it was growing stones,' Goldsworthy remarked, 'because ground frost would just push more and more of them to the surface each year.' Wall-building was, among other things, a way to dispose of the seemingly boundless quantities of stone coughed up by the land that early European settlers were determined to farm. In this respect, the oldest stone walls of the American northeast are akin to those of England and Scotland. 'I've got photographs of walls in the Storm King area that would not look out of place in Scotland,' Goldsworthy said.

Another of Goldsworthy's projects on private land in Westchester County, New York, explicitly evokes the burden it must have been to early farmers of the area to have new stones perennially surfacing. In a town where stone walls, old or new, stand today between expensive houses and the street, Goldsworthy's is the one most likely to make a passing motorist's head turn or stop a walker in his tracks. A long stretch of dry-stone wall is abruptly interrupted by a gap that looks at first like a gateway. In fact, the gap is a set-back section of wall within which a single giant boulder appears to levitate. Two others like it stand farther along the wall. In each of them, a massive boulder sits, above ground, embedded in a ribbing of vertical slate slabs. The buff-colored boulders (found by Goldsworthy when they were uncovered on a construction site nearby) stand out against the dark gray slate like gemstones in settings, although he says he chose the boulders for their form, not their contrasting color.

Above: Boulder uncovered on construction site.
Below: One of the boulders selected for Three Roadside Boulders being placed in position.

The elevated boulders are emblems of field stone itself, the vertical 'grain' of the slate pushing them up visually, as glacial detritus of all sizes has for centuries been pushed to the surface by ground frost. The shock of seeing the wall-bound boulders recapitulates a movement of one's attention that occurs almost subliminally with all of Goldsworthy's wall works. Sooner or later in the exploration of a Goldsworthy wall, individual stones catch one's eye. They may be the long 'through stones' that protrude from a wall to serve as a step, or stones of no obvious distinction. Once that happens, the eye begins shuttling between the larger structure and the elements that comprise it, no matter that we know that Goldsworthy himself neither shaped nor positioned the vast majority of them.

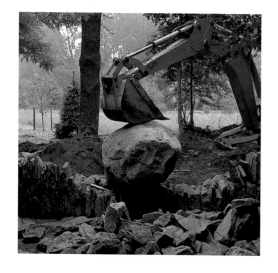

Anyone who has seen wallers at work knows that a wall is a plenum of ad hoc decisions. Sometimes building it entails splitting or hammering stones to suit, but mostly it is a matter either of finding a place for what comes to hand or tossing that aside and choosing another from a heap. For this reason, I see the boulders that adorn the Westchester wall partly as tributes to wallers past and present, the men (and in America at least, a few women) who helped stones on their passive journey up from and across the earth.

Three art connections came to mind when I saw Goldsworthy's boulder-studded wall in Westchester. The first is to his own Sheepfolds project. The second is to a work Goldsworthy

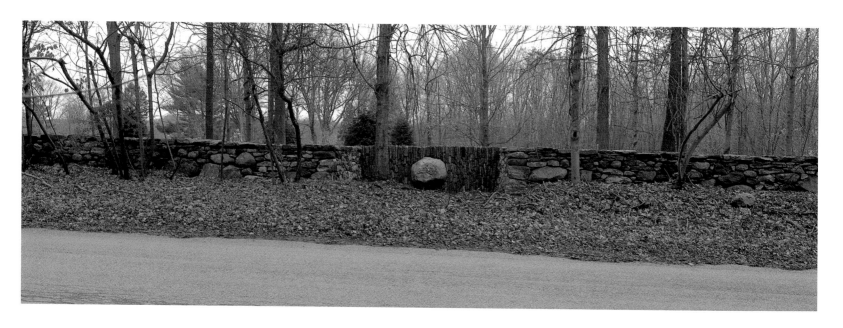

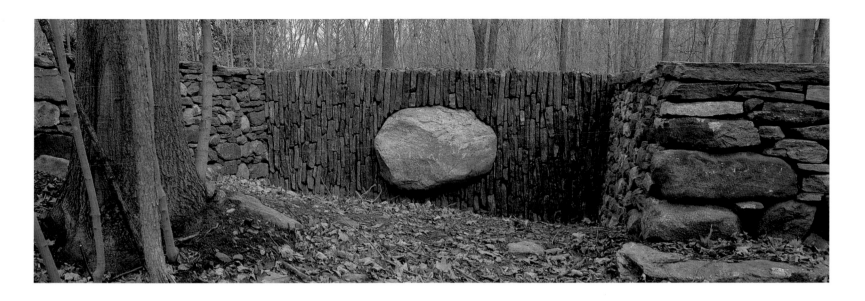

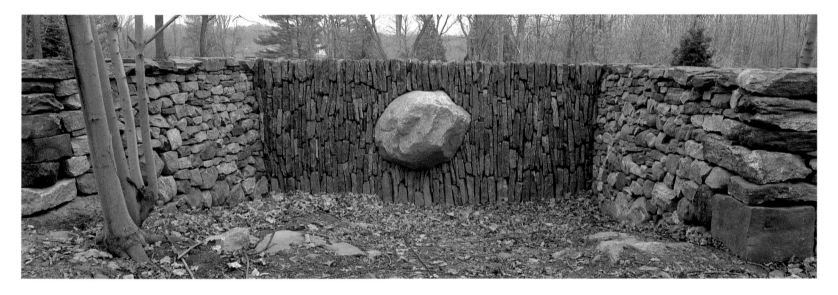

did not know before I mentioned it, the minimal sculptor Carl Andre's 'Stone Field Sculpture' (1977) in Hartford, Connecticut, about 60 miles east of Westchester. The third is to certain paintings by the Belgian surrealist Rene Magritte (1898-1967).

Goldsworthy's Sheepfolds are his most unobtrusive 'permanent' works. Most of them merge seamlessly and functionally with the sheep farming that still goes on around them, as it has for centuries. But several stand out slightly because Goldsworthy has placed a large boulder within each one. From a distance, the top of an enfolded boulder may look like the back of a gargantuan sheep. But step down inside the fold with it, and the boulder starts to seem enshrined. To the sheep, the boulders are convenient for scratching and enhance the shelter offered by the fold itself. The lanolin from their wool rubs off on the stones, giving them an almost metallic patina that can bring Henry Moore to mind. The sheep become unwitting collaborators in the boulders' conversion to sculpture.

The idea of turning boulders into public art by repositioning them has an American precedent in Andre's 'Stone Field Sculpture'. On a triangular plot of public land across

Opposite and above: Three Roadside Boulders, Westchester County, New York, 1996. Stonework by Steve Allen, Gordon and Jason Wilton, Bill Noble and Andy Goldsworthy.

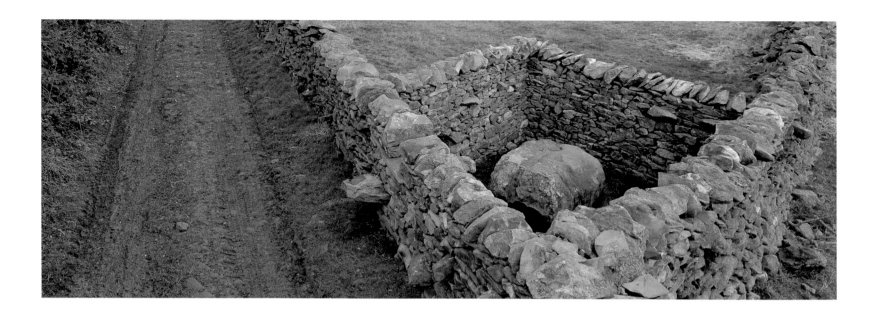

Above: One of Fifteen Drove Stones, part of the Sheepfolds project, Casterton, Cumbria, 1996.

from the Wadsworth Atheneum, Andre placed a spacious triangular array of 36 uncarved boulders. The largest stone is the triangle's apex; they get smaller as their number increases, row by row, ending with eight at the triangle's base.

Andre is known for keeping his work as unartifactual and structurally simple as possible. His placement of unaltered field-stone boulders spaced out in rows is partly a refusal of the possibility of wall building, as it is of carving. Andre's refusal to carve is rejection not only of imagery but of what he sees as a false artistic choice between image-making and abstraction by which many 20th-century sculptors have steered.

But there is wry subtext to Andre's piece that makes it recognizable as the work of an American artist. Andre is a native New Englander who knows it was traditional for New England hamlets to adorn their town squares with boulders that – sometimes with the addition of a inscribed brass plaque – serve as readymade monuments. Each such boulder is a symbol of Plymouth Rock, the legendary disembarkation point of the pilgrims who settled the Massachusetts Bay Colony in the early 17th century. (In modern times, the emblematic rock itself has taken on divisive associations, summed up in Malcolm X's deathless rallying cry to African Americans: 'We didn't land on Plymouth Rock. Plymouth Rock landed on us!') Thus each town-square boulder silently celebrates the founding of the New World. Little wonder that, beyond the fact that it was bought with public funds, Andre's piece was controversial when it was first installed. Many of Hartford's citizens have warmed to it since.

The overtones in Andre's use of boulders are very different from those of Goldsworthy's boulder-levitating wall, even though both artists have used the same materials and referenced the region's past with great economy. Andre intended his unworked boulders to be stopping points, to blockade people's habit of seeing the world according to certain received ideas and force them either to rebound from it or else insist upon it with embarrassing vehemence. But Goldsworthy, as he says, does not have the 'tendency to push the work into division and conflict' that he sees in American land art, and that people rightly saw and felt in Andre's 'Stone Field Sculpture'.

The shock of coming upon boulders floating above the ground is what brings Magritte to mind. In several famous paintings, notably 'A Sense of Reality' (1963) and 'The Castle in the Pyrenees' (1959), Magritte depicts massive boulders afloat in the sky or in other physically impossible positions. Magritte's levitating boulders make us sense the absurdity of pictorial representation: its freedom from gravity, its detachment of sight from the rest of the senses. Counterparts of his vagrant boulders are the images such as 'Memory of a Journey' (1951) and 'The Song of the Violet' (1950) in which everything appears to be made of stone, as if the eye that looks to representation for meaning had a petrifying gaze itself.

Magritte's conundrums often come to mind around Goldsworthy's work. Besides the elevated boulders in Westchester, there is something Magritte-like in the way he nestled a slate cone in the corner of a sheepfold in Grizedale Beck, Cumbria, for example.

'Surrealism doesn't interest me generally, but Magritte really does question how we see things,' Goldsworthy said when I mentioned him. A crucial difference, though, is that Magritte painted to rebuke the purported rationality of a culture thoughtlessly reliant on images and their implicit cross-references. Goldsworthy too is critical of the limits of conventional vision. But where Magritte was interested in the dangerous illusions bought by magical elimination of the third dimension, Goldsworthy is more interested in what disappears when we lose sight of the dimension of historical depth in the real world.

Nature withdraws – and the nature in us accordingly becomes alien to us – when we can see a landscape only as a picture or as real estate, blind to its history of human involvement. Goldsworthy's ephemeral works using leaves, twigs, snow, water and light attempt – by example – to resensitize us to a resourceful vision of natural forms of the kind that our ancestors often depended upon for survival. Perhaps that sensitivity can now be reawakened only as aesthetic perception. Be that as it may, the way of seeing encouraged by the ephemeral works can act as a prelude to a longer essay such as the Storm King wall that can show us, as Goldsworthy once said, how to 'see history even in a heap of stones.'

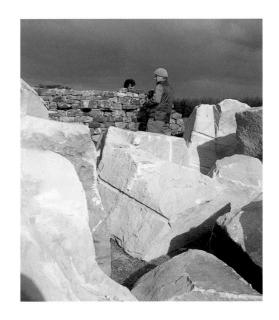

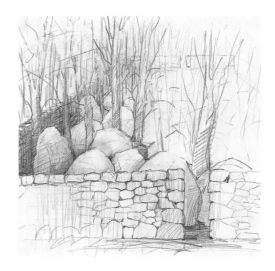

Above: Stone Gathering (under construction), Northumberland, Spring 1993.

Below: Proposal drawing for Storm King (detail), pencil on paper, 56 x 76 cm, 1997.

STORM KING

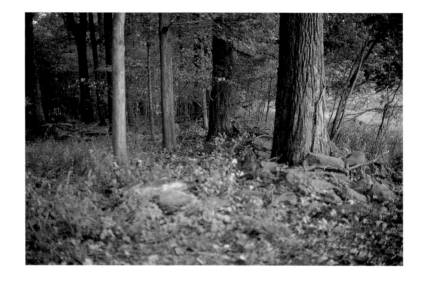

The site

Opposite
Proposal drawing (detail)
pencil on paper, 56 x 76 cm

1997

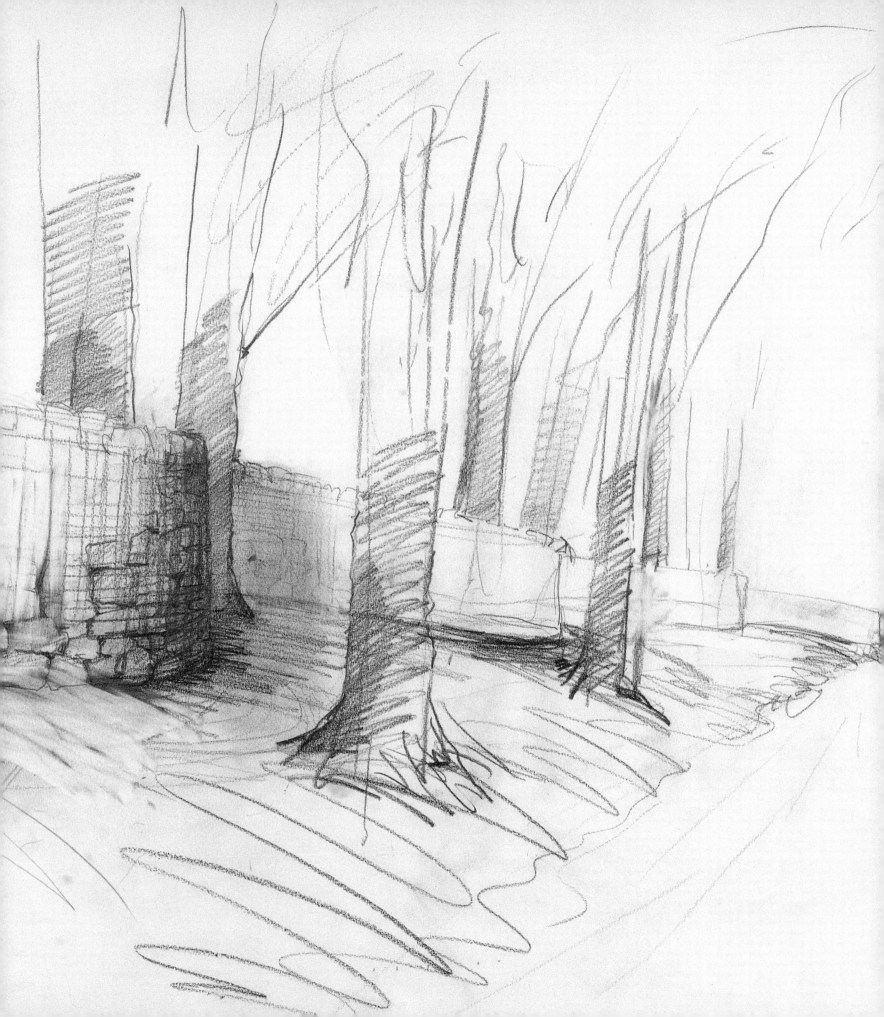

I was invited to propose a work for Storm King Art Center in 1995. There was no restriction placed on what I should make or where I should work. I spent several days walking, looking and occasionally making ephemeral works – getting to know the place.

Since 1984, I have from time to time undertaken commissions that could be described as permanent. In some ways these permanent works can be seen as a contrast to my ephemeral work. Whilst the two approaches are obviously connected, they remain very different in intention and the way that they function.

Many, if not all, of my large permanent works have their origin in leaves, branches, snow, ice . . . Works do not arrive large immediately. Ideas and form often grow in scale through repetition. This is necessary to prevent a large work becoming heavy-handed, out of scale or out of control. The process echoes that of growth itself. A tree has to put down strong roots to support its weight above the ground. It is the same with sculpture. What is not seen – the preparation and previous works – underpins what is made visible in the piece itself.

I try whenever possible to make one or two ephemeral works each day. These works are made for a particular place and may last anything from a few minutes to a few days. They are an exploration of the land, often made without knowing what the result will be. They are intuitive responses to light, material, time, weather. The need to make mistakes, and sometimes to produce bad works, is part of the process. I have far more failures than successes. This is how I learn.

My approach to permanent works is very different. They are much more thought-out and reasoned, and are often preceded by drawings and discussions (which are rarely needed for the ephemeral work). I take seriously the responsibility of leaving behind something that will last a long time. There is not the room for error that I have in the making of ephemeral work. Of course there is an element of chance in any piece, but I have to feel that it is very likely that a permanent work will succeed before I embark upon it. The social nature of the work – at its conception, throughout its construction and later, as people respond to it over the years – provides a very different context for me to work in from that of the ephemeral works.

The ephemeral works provide the ideas and feelings for the permanent works, and I need to keep a balance between the two – not unlike having a bank account from which I can only draw out what I have put in. The ephemeral is the breathing in, the nourishment, whereas the permanent is the breathing out.

I understand best the places where I have worked most often. I have a large well to draw on when realising works in Britain and consequently most of my permanent sculpture has been made there. In a different country, I inevitably feel a stranger and in order to achieve a strong work I often tap into this well. To be successful, the work must be rooted firmly in the new place, while drawing on the connections with my home.

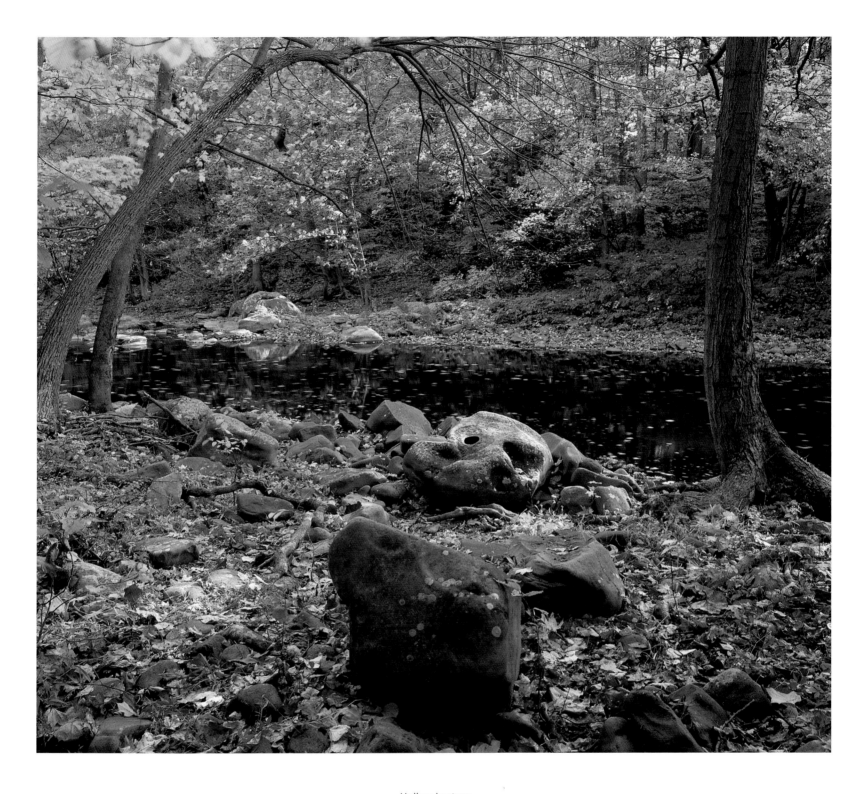

Hollow in stone

clay worked around its rim

drawn to an edge

enclosing a hole

STORM KING ART CENTER

19 OCTOBER 1998

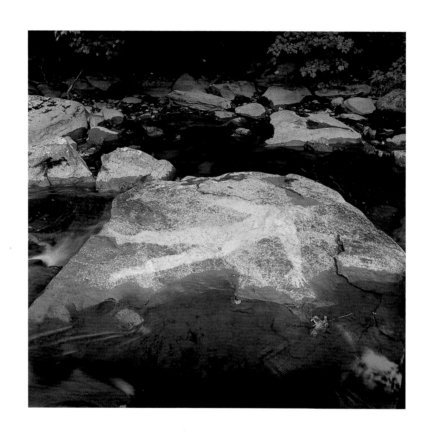

Five water drawings
(one rain shadow)
on the same rock

STORM KING ART CENTER

SEPTEMBER 1997

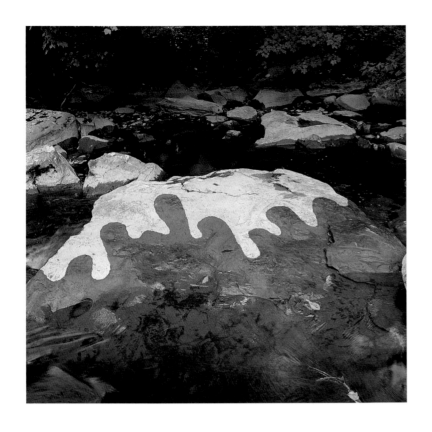
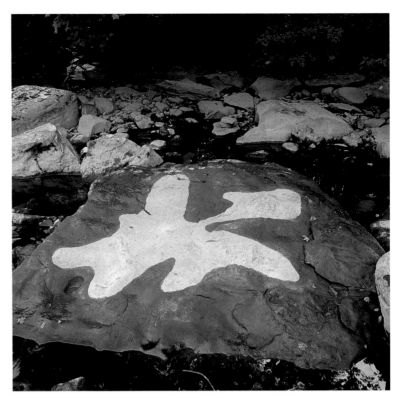
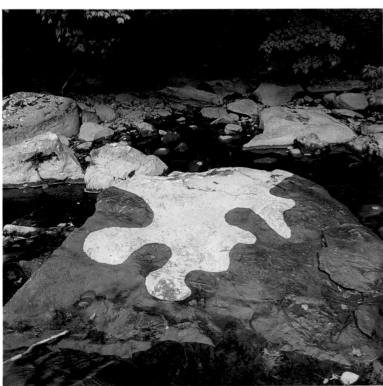
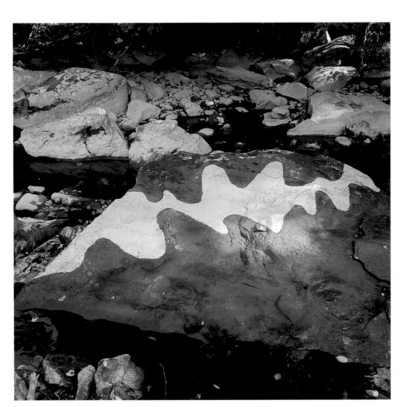

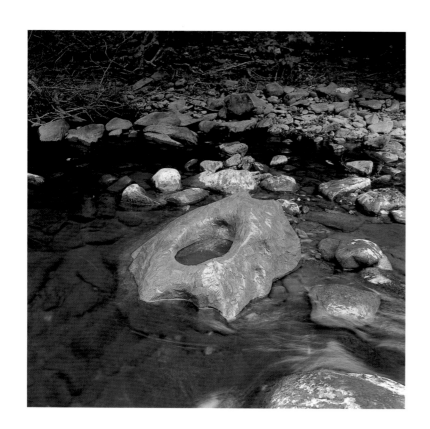
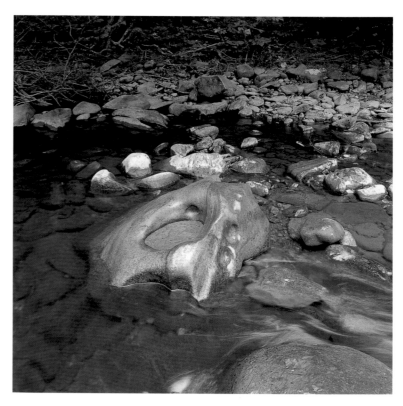

River rock
pool
green leaves
held to rock with water
returned later the same day
removed remaining leaves from the rock
laid them on pool

STORM KING ART CENTER
23 SEPTEMBER 1997

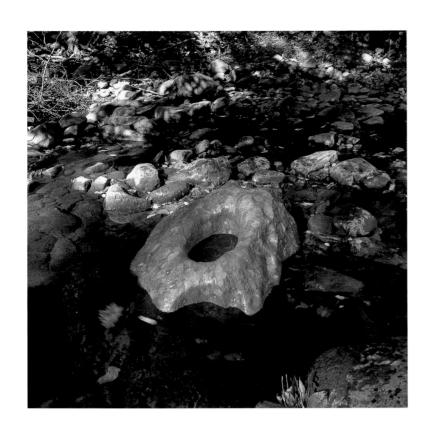

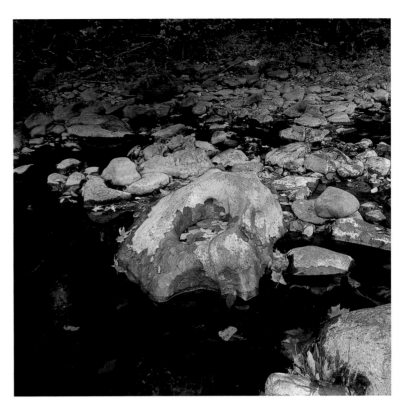

River rock
red leaves
held to rock with water
returned later
laid leaves on pool

STORM KING ART CENTER

OCTOBER 1997

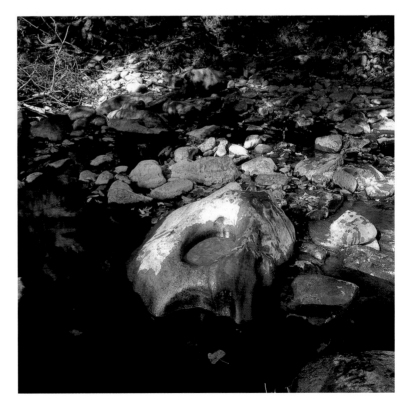

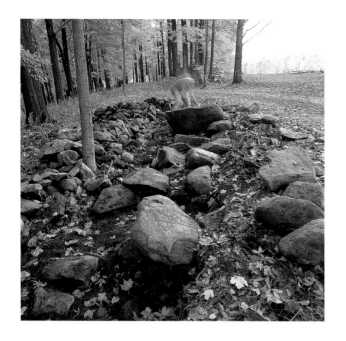

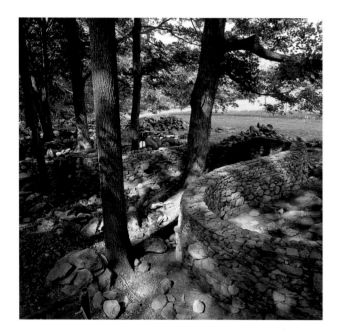

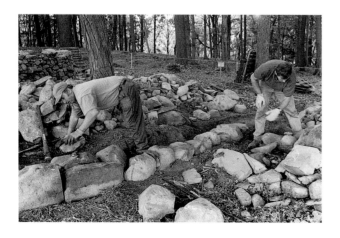

I have generally been more satisfied with the wall sculptures I have made that relate to an old wall. I like the resonance of making an old wall new again, and allowing it to change in response to the place as I find it.

There are many derelict walls at Storm King. I found one of which very little remained, but its lie could be picked out by the straight line of trees growing along its length. On one side of it was a field and on the other, regenerated wood. The largest trees were those growing out of the wall itself. The original wall was made when the forest was cleared, from stones ploughed out of the field which it then marked off and enclosed. Although the wall's initial purpose was to help turn the forest into agricultural land, it then provided the shelter which allowed tree seeds to germinate and eventually to grow alongside and even within the wall itself. In the end the wall collapsed, leaving a straight line of trees as evidence of where it had been. Originally victims of the wall, the trees grew back and, in their turn, caused the wall's destruction.

In building the new wall, I have reworked and continued this dialogue. The wall has been remade, but with a new role. It now follows a line in sympathy with the trees, working around each one in a protective enclosing gesture, rather than requiring it to be cut down.

The line of trees that grew out of the old wall dictated the line of the new. I walked in and out of the trees many times to find the right direction, flow and feel. Its route was then marked out. The first section of the new wall is built directly on the foundations of the old, before diverging from it. Parts of the old footings have been left – evidence of where the original wall once stood.

There is a difference between a designed line and a line that has been drawn out of a place. The lie of the land forced the wall to respond to diffficulties, and solving these made it the richer. As the wall began to work the space into which it was being built, it occasionally changed direction. I started around the middle of the wall's length, where the trees grew closest together and where the main difficulties would be met early on. These could only be resolved in the making.

Above: foundation stones of the old wall, eastern section.

Centre: middle of the eastern section under construction.

Below: laying the foundations of the new wall, eastern section.

Opposite: new wall (middle section) and foundation stones of the old wall.

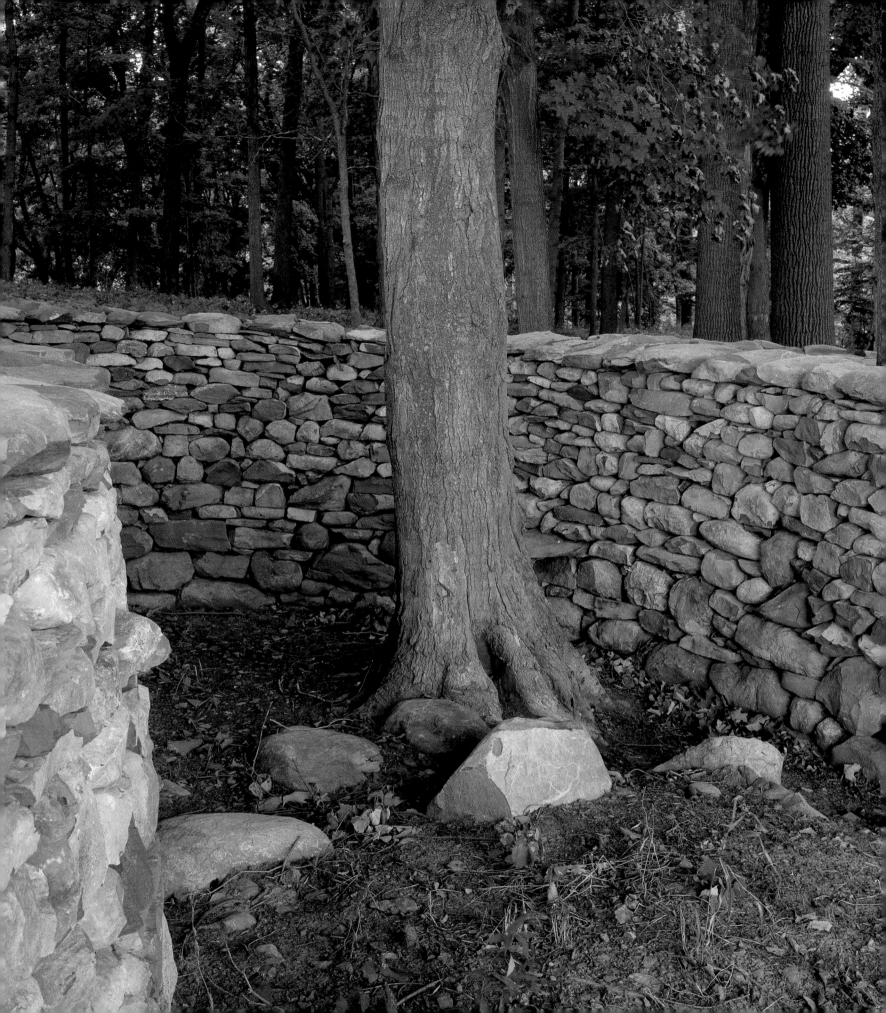

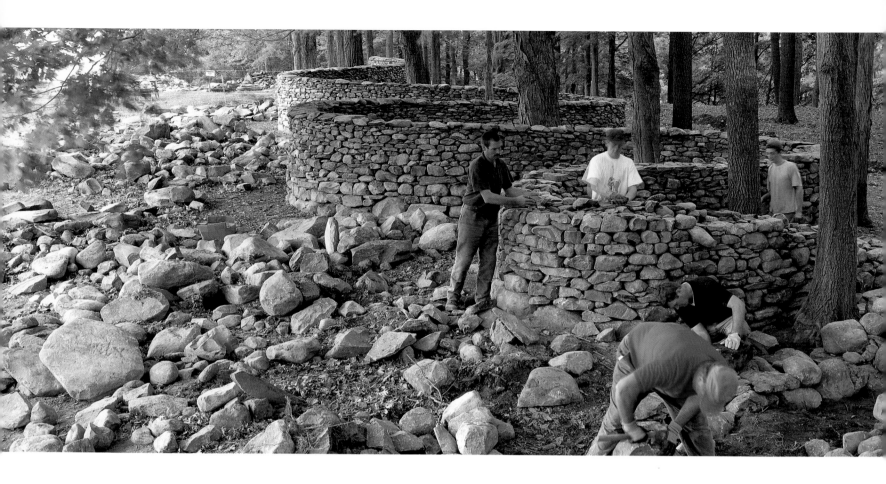

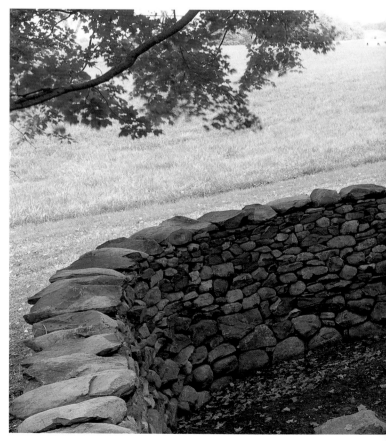

Middle section, 1997.

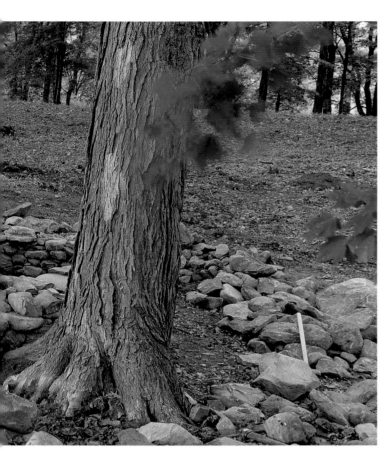

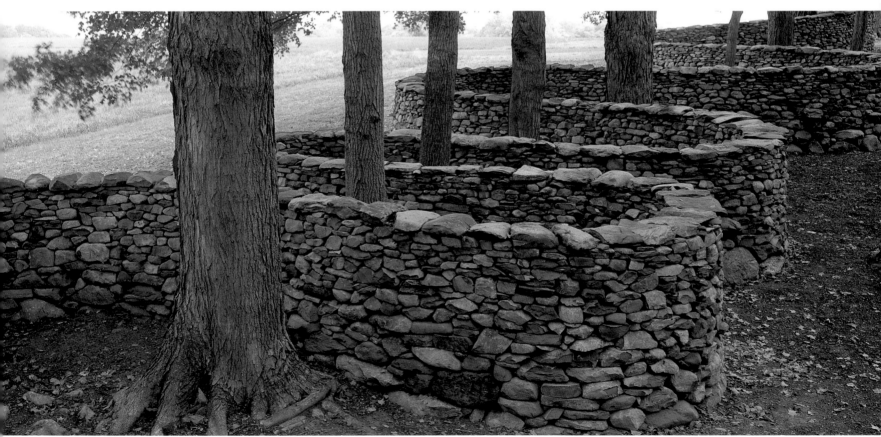

Rushes

gently bowed

slipped over thorns pushed into tree

DUMFRIESSHIRE

14 AUGUST 1999

Dried bleached grass stalks
tensed
between ridges of bark.

ORANGE COUNTY, NEW YORK

AUGUST 1999

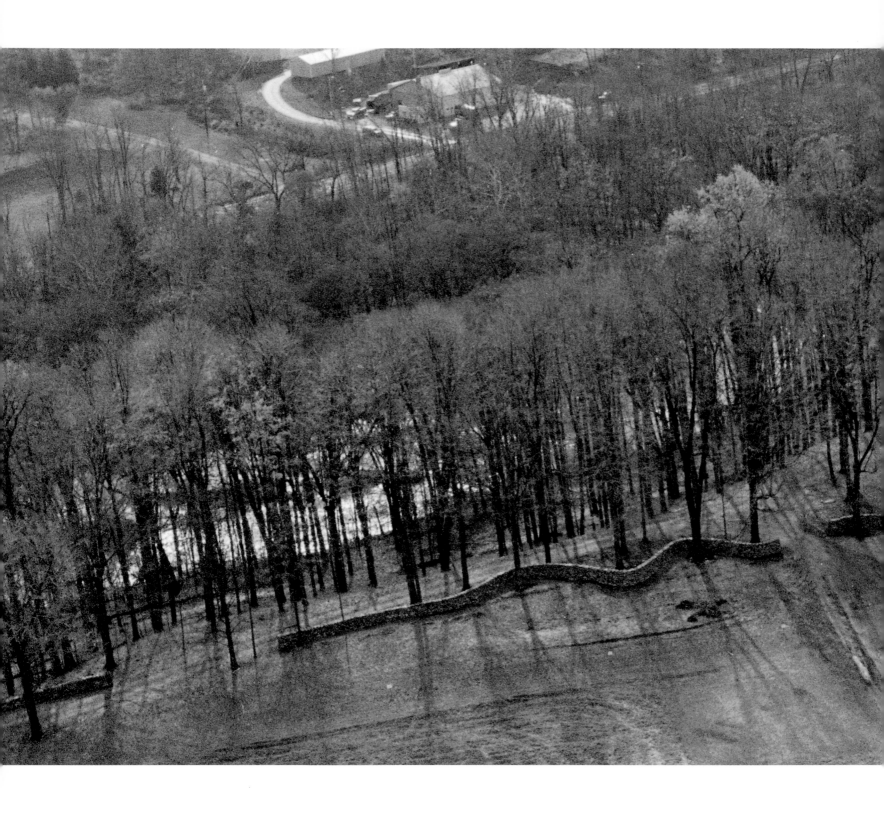

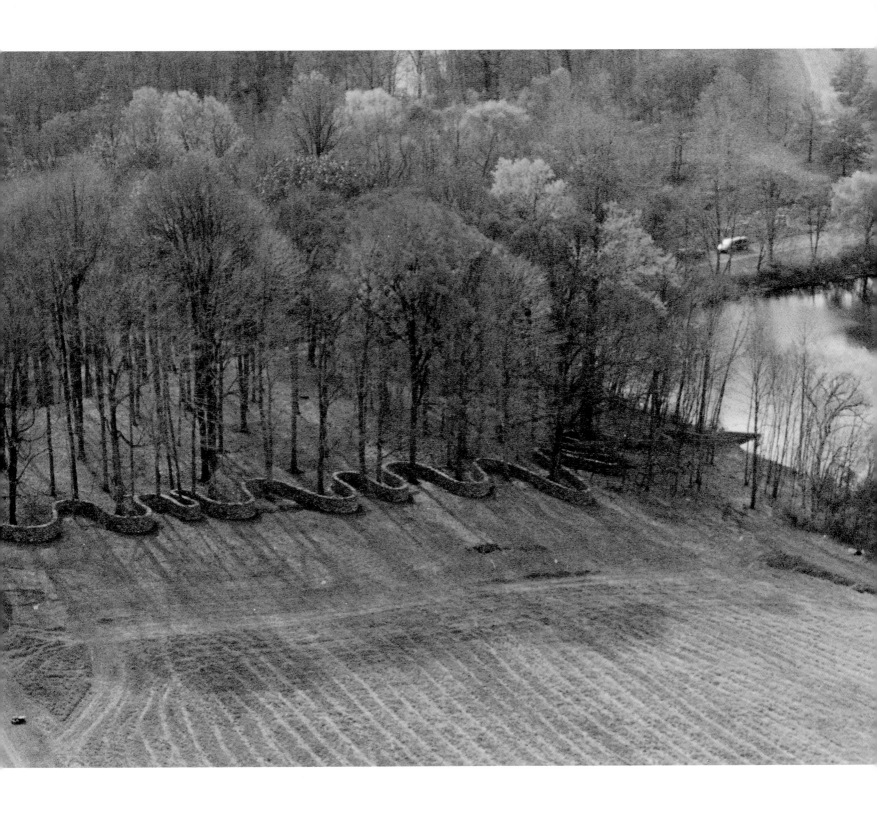

Searching out lines that already exist interests me more than imposing new ones. I have made lines that explore and follow the contours of a rock, the edge of river, the growth of a branch, the junction between house and street . . . Pressing leaves into the bark of a tree produces lines dictated by the tree's growth patterns. The intention is not just to make a line, but to draw the change, movement, growth and decay that flow through a place.

Opposite
Overnight rain
damp, overcast morning
leaves pressed into bark
drying and falling off

STORM KING ART CENTER
14 OCTOBER 1998

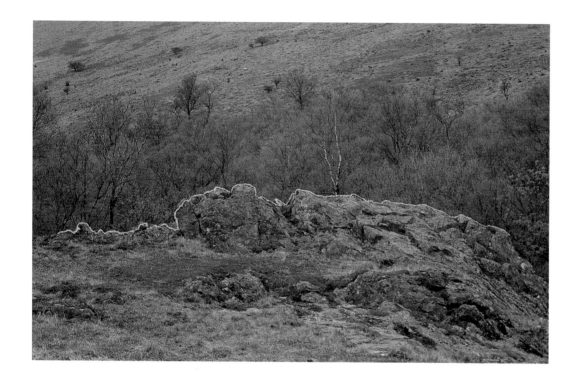

Dandelion lines

DUMFRIESSHIRE
MAY 1994

CAHORS, FRANCE
APRIL 1996

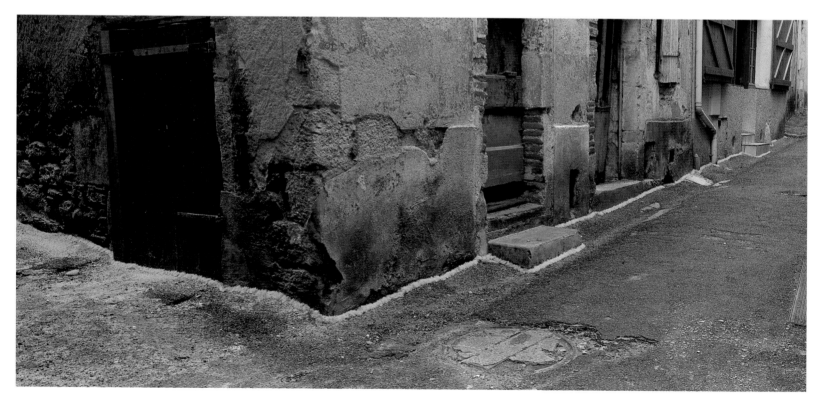

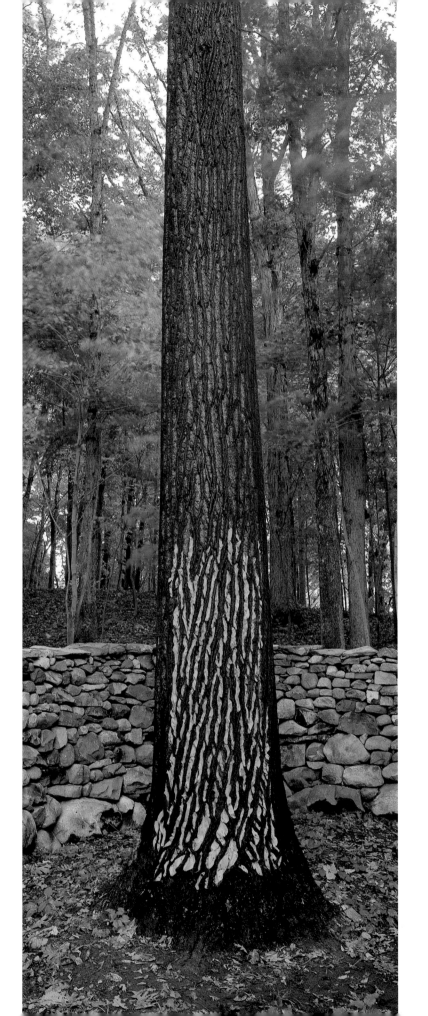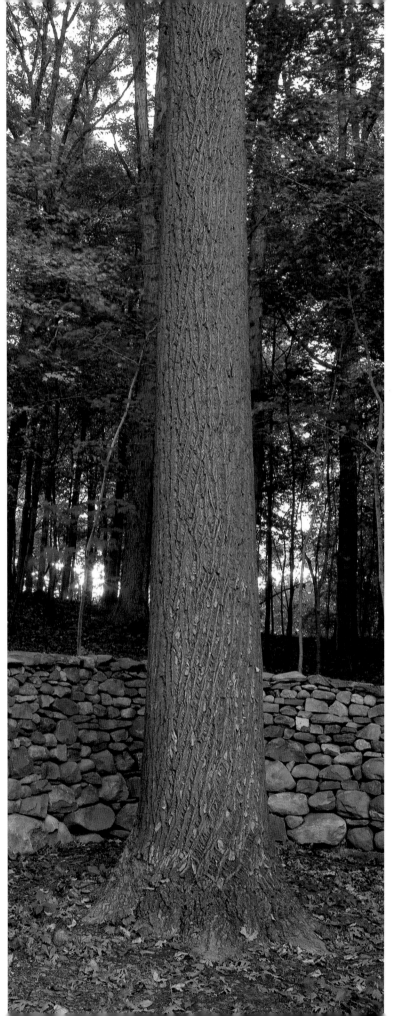

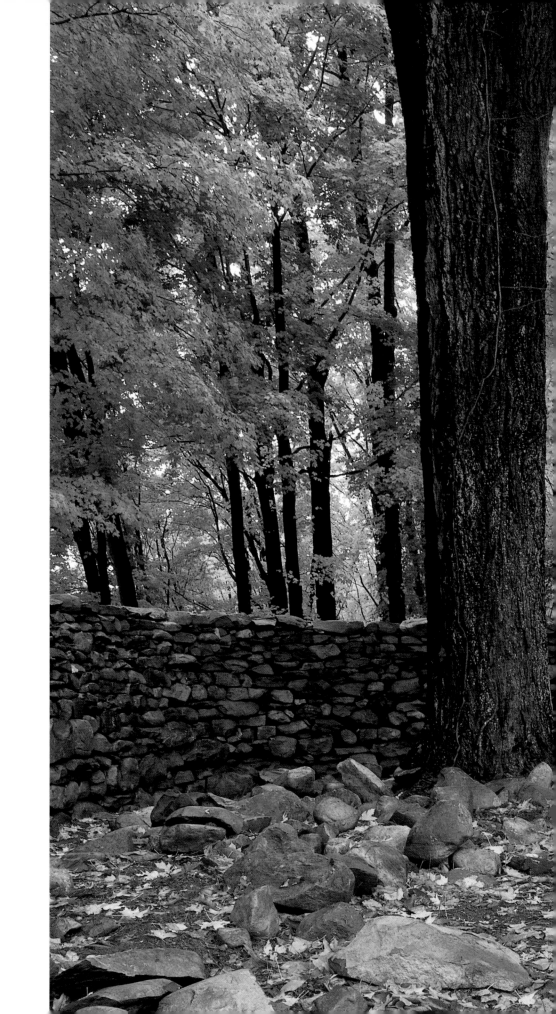

Rain
yellow leaves torn into strips
placed on wall

STORM KING ART CENTER

OCTOBER 1997

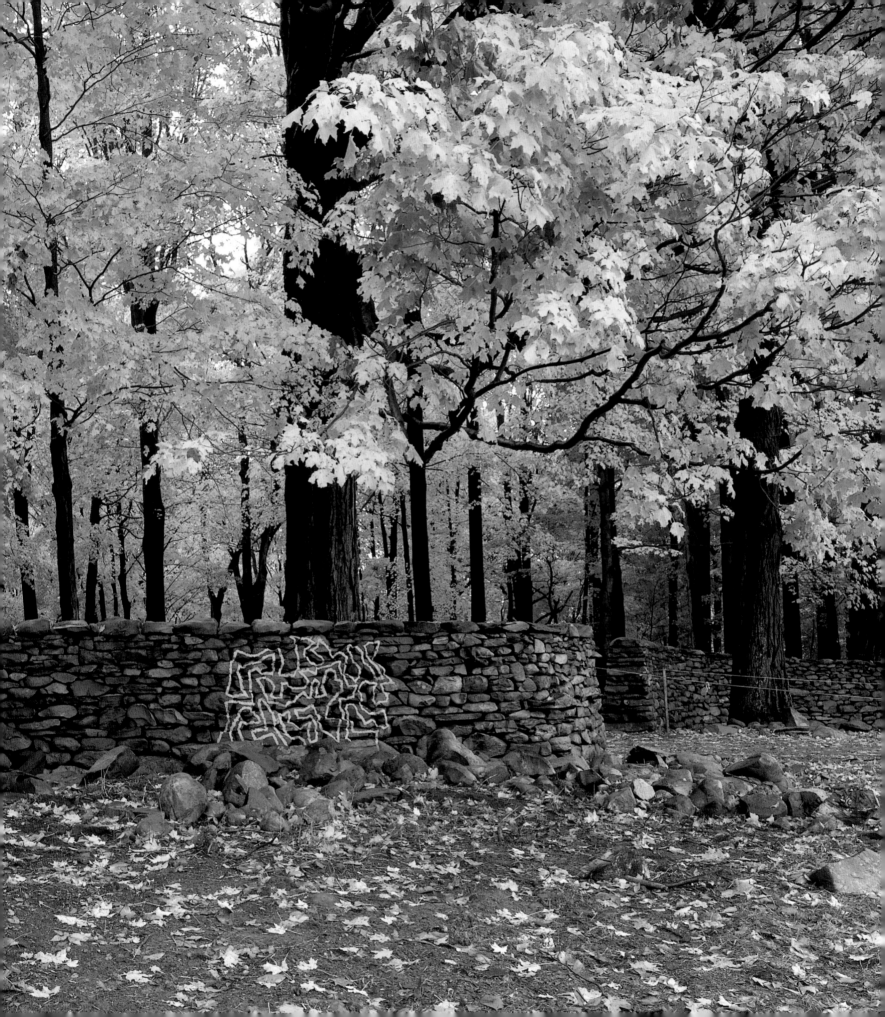

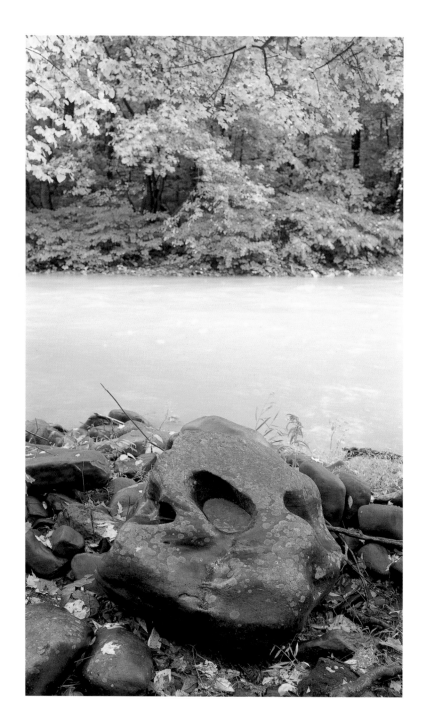

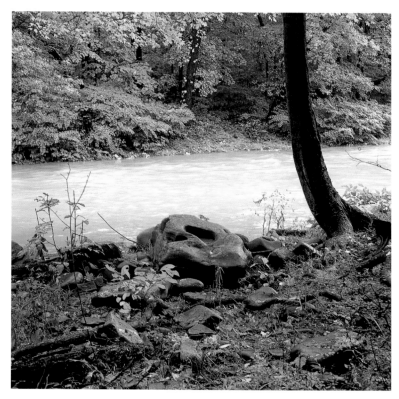

Two stones
America and Scotland
red leaves laid in one
and yellow leaves in the other

STORM KING, NEW YORK

OCTOBER 1995

PENPONT, DUMFRIESSHIRE

NOVEMBER 1995

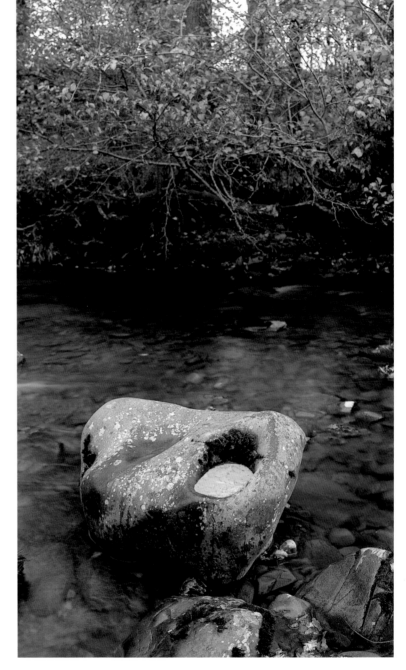

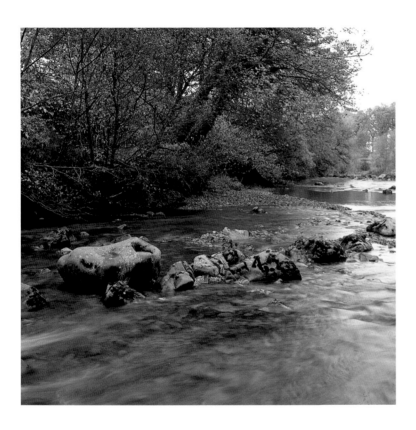

When I work with a leaf at Storm King, I bring to it my understanding of leaves worked in Britain. One of the first works I made at Storm King was in an eroded hole, containing water, at the heart of a stone next to the river. I covered the pool with red leaves. I was reminded of a stone that I know in Scaur Water, a river near my home.

On my return to Penpont, I went to this rock and made a yellow leaf pool. If red is a colour of the American fall, then yellow is the colour of the Scottish autumn: these two works reflect differences in colour, season, stone and water, but at the same time make connections. Two holes worn out of two stones in different countries are nevertheless an expression of the same energy at work.

Dry-stone walls have also given me a way of understanding Storm King, providing a connection, while at the same time making me aware of differences. These walls were probably made by immigrants from Europe, but here they have completely lost their agricultural purpose and are derelict and overgrown. Coming from Britain where walls contain and divide fields, farms and mountains, I find it strange to see this. The American walls have changed the way I see walls in Britain. They carry both the memory of farmed land that has now vanished and a vision of how Britain would look if the trees were allowed to come back and agriculture did not keep them down. The absence of woods in the British landscape is made more poignant by their presence in the once-farmed American landscape.

The first wall sculpture that I made in this area of the States used a wind-fallen tree that I cut in half and incorporated into the wall on each side of an opening. It is a reminder of the trees that were cut down when the wall was first made. A person passing through this entrance also passes through the tree, dividing it in half.

I find the relationship between stone and wood powerful and poetic. In 1989, I was given a small piece of land near where I live on a long lease by The Buccleuch Estates. I called it 'Stonewood'. The first sculpture I made there was a slate stack to act as guardian to a much-abused and burnt oak tree. The second was my first wall sculpture. This wall divides the land that I had been given from the field of which it had been a part. Since the wall was built, sheep have been prevented from entering my side (except for the circular enclosure which projects into Stonewood). Originally I had planned to put a sculpture in the other circular enclosure, which opens out from my side into the neighbouring field, but the dramatic regeneration of the wood has made this unnecessary. That this wall became a protector to the wood provoked many of the feelings and interests that led to my making the Storm King wall.

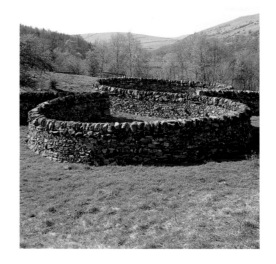

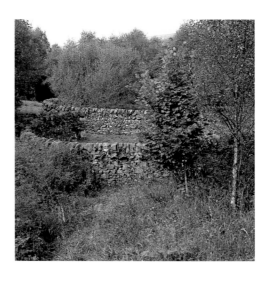

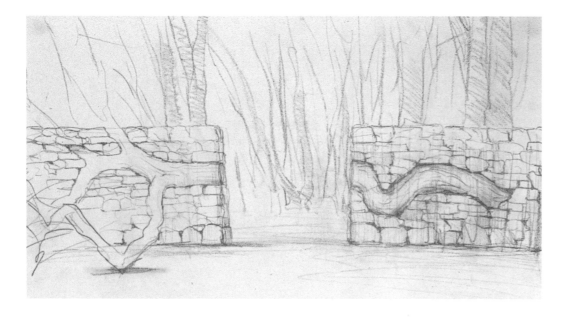

Give and Take Wall, Stonewood, Dumfriesshire, *top:* 1989; *above:* 1999.

Left: Proposal drawing for Wood through Wall, Westchester County, New York, 1993.

Opposite: Beginning of eastern section of Storm King wall, incorporating (*far right*) tree found growing through foundations of old wall.

42

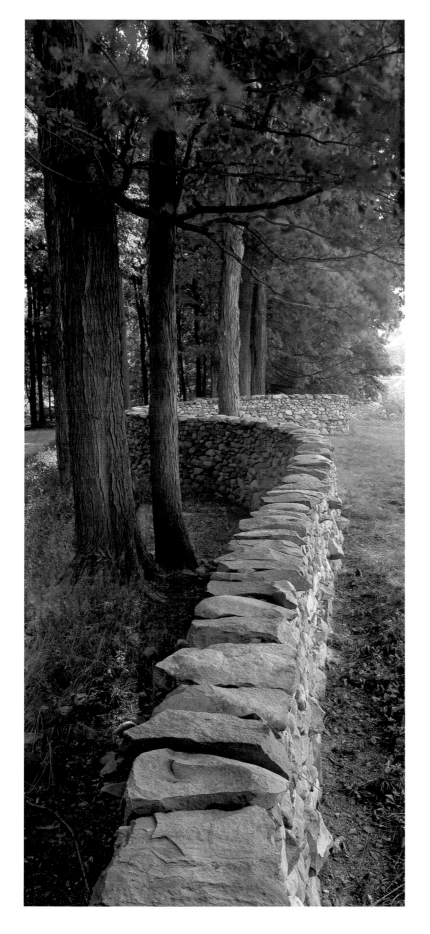
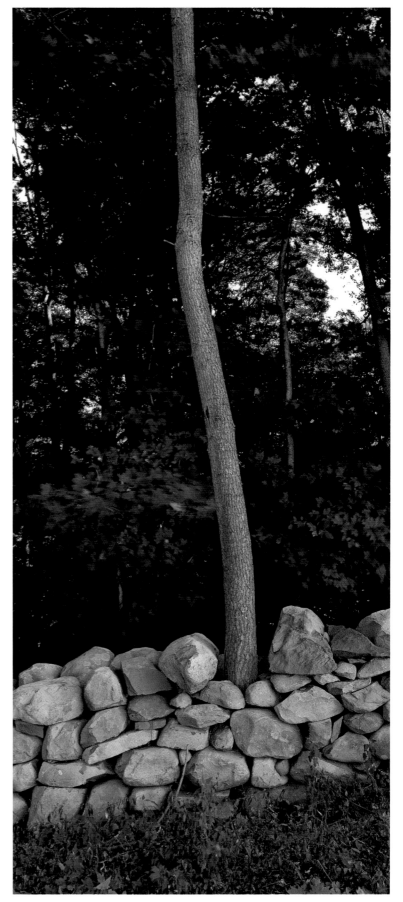

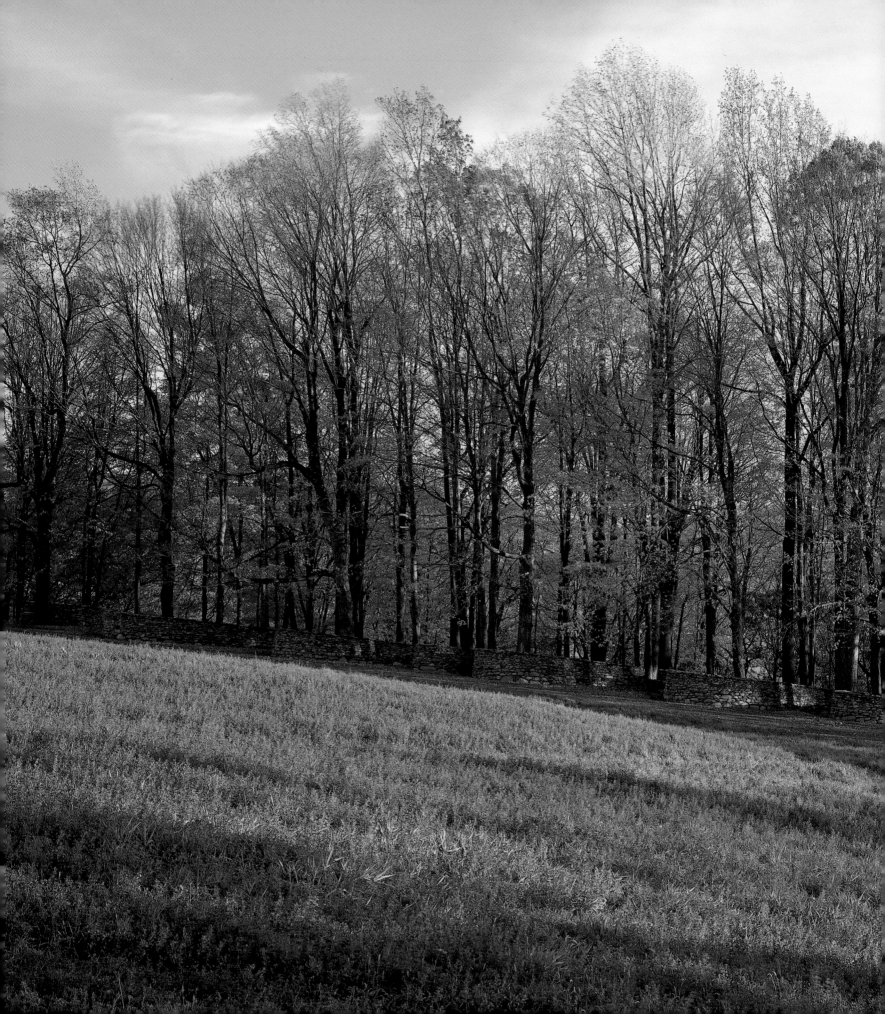

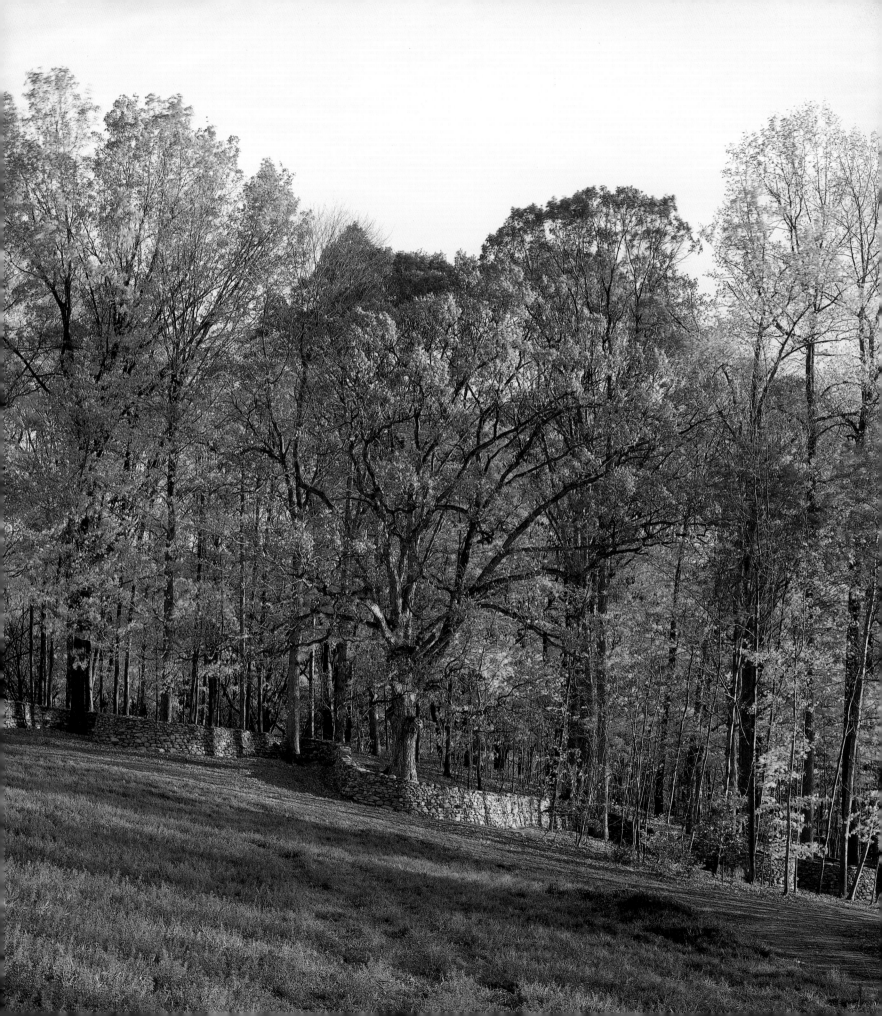

The way a wall is made is determined by the type of stone, the site and the surrounding area. At Pound Ridge and Mount Kisco where I had worked previously, the stone is heavy and rough, resulting in thick, squat walls – very different from those at Storm King which was farmland until much more recently. The soil is deeper and the stones smaller. Certainly the walls here are closer to those I know from Scotland and England. The stone is almost the same as that to be found where I live.

The difference in the stone and the walls of Storm King from others in the area has made me concerned that people will see this wall as out of the ordinary and read too much into the manner of its construction. It is a fact, however, that any rebuilt wall will look different among derelict walls, so I am forced to accept that mine will be more noticeable than I would like it to be.

Walls in Britain are by their nature constantly changing: they have to be kept up, and from time to time remade. Rebuilding old walls is very much part of the walling culture where I live. It is much more than the simple act of repair. For me, it is an expression of nourishment, renewal, change and continuity. The walls I have made in Britain are connected to a network of walls made in the same way.

In America there is no clear tradition of rebuilding walls, and when they are remade, the construction method is usually very different to that of the original.

The Storm King wall was made by wallers from the north of England and Scotland, where the tradition of making and rebuilding agricultural walls is strong. Most wallers come from farming backgrounds. The walls that farmers make are constructed not just for their appearance, but for their strength and durability. Stones turned up in the course of ploughing the fields are used to make the walls that will enclose the fields. The cyclical process of building and rebuilding a wall is related to the cycle of farming itself. The hand that made the wall also knows the planting of crops and the tending of animals.

I acknowledge the extraordinary craft of wall-making, but my art lies in the line taken by the wall and its relationship to place rather than in the method of its construction.

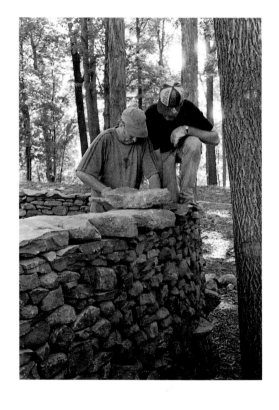

Above: Wallers at work on the middle of the eastern section of the Storm King wall.

Left: Existing wall in the vicinity of Storm King Art Center.

Opposite: Wall end at first opening in eastern section, Storm King, 1997.

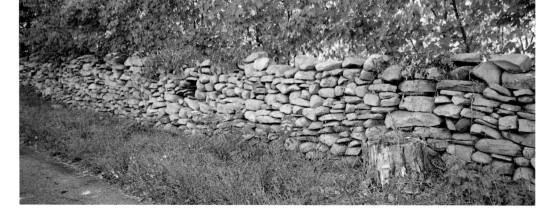

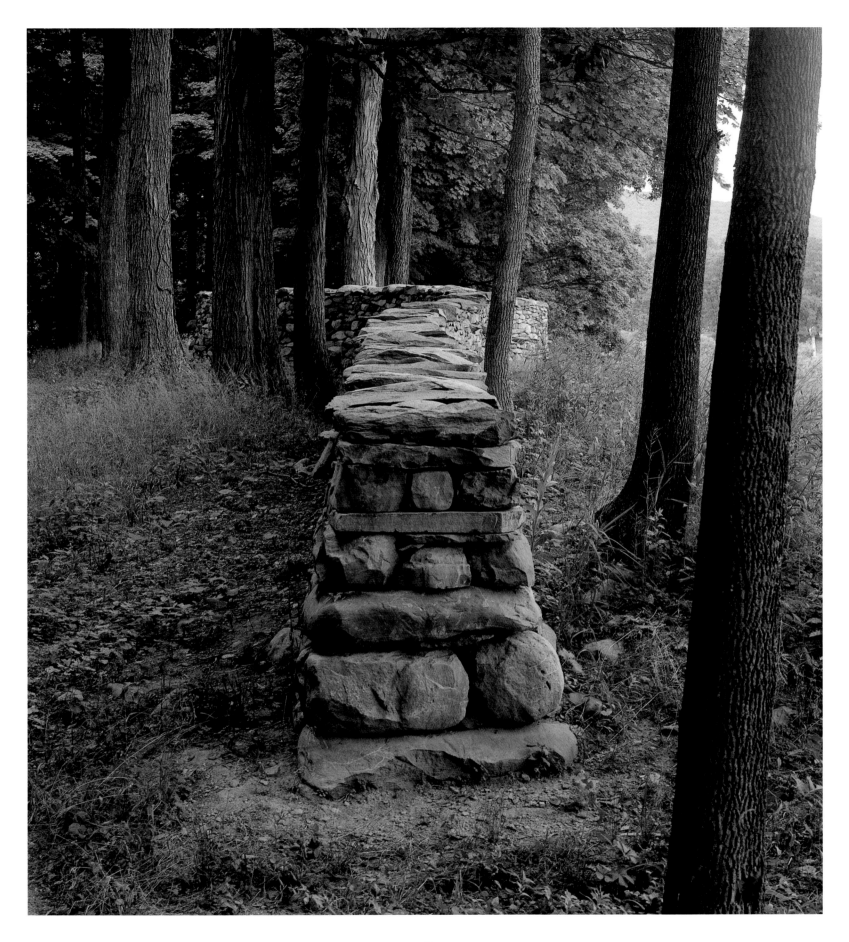

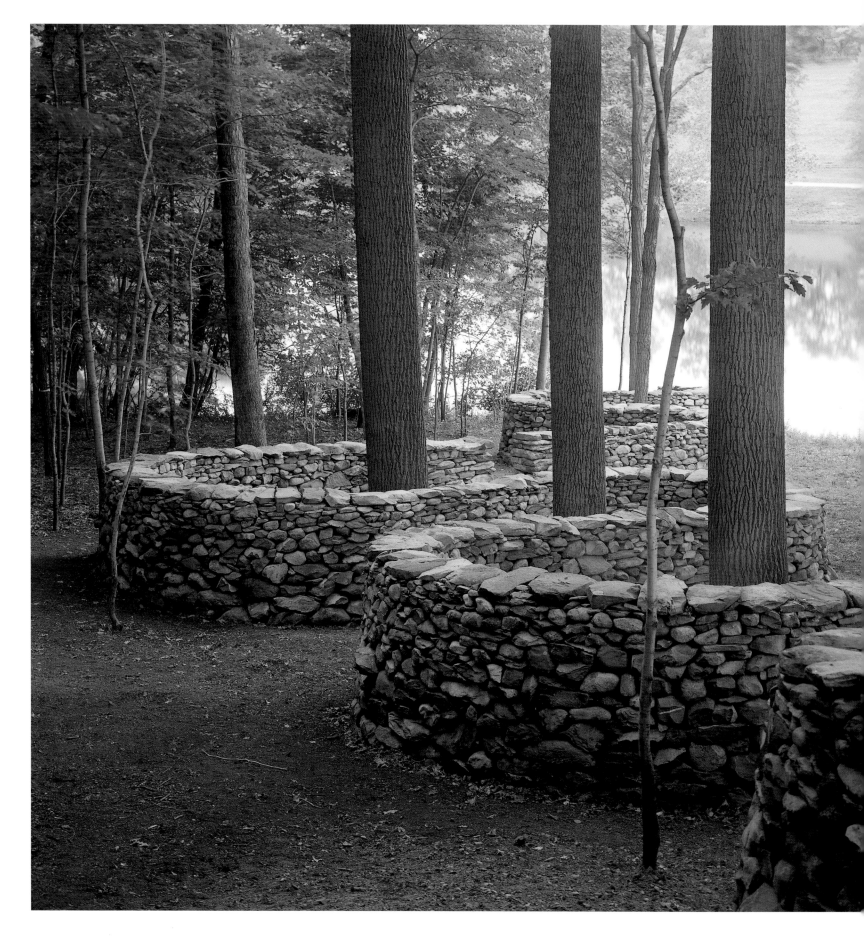

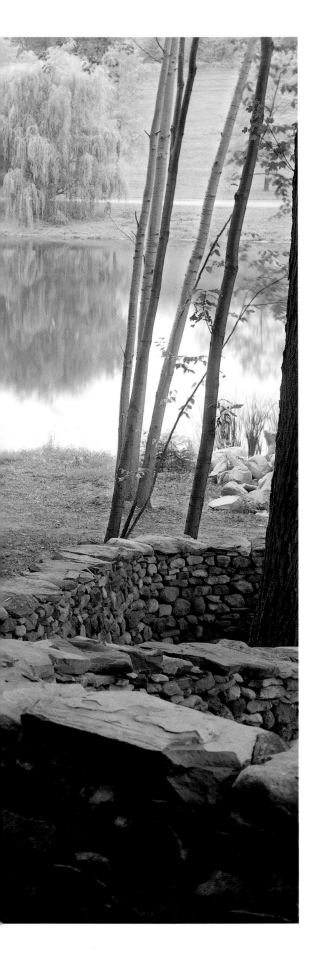

Initially, it was intended for the wall to stop short of the lake at a large oak tree, where the original wall also ended. In the making, however, the new wall built up such a momentum that it willed itself beyond the tree and into the lake.

The route from the oak tree to the lake was the hardest to find without the original wall to guide me. At first, I tried to take the most direct route, but in the end, I was drawn to a line of large trees, slightly over to the left, looking down towards the lake. Initially I resisted this direction for fear that the wall would lose some of its sense of movement towards the lake. When it was completed, however, I realised that this slight shift gives the wall more energy and in retrospect I cannot see why I was so undecided. This now seems the most obvious route for it to take.

Left: Wall descending towards the lake after having changed its direction at the point where there was no longer any trace of the old wall's course.

Below: Looking east from opening between eastern end and middle section.

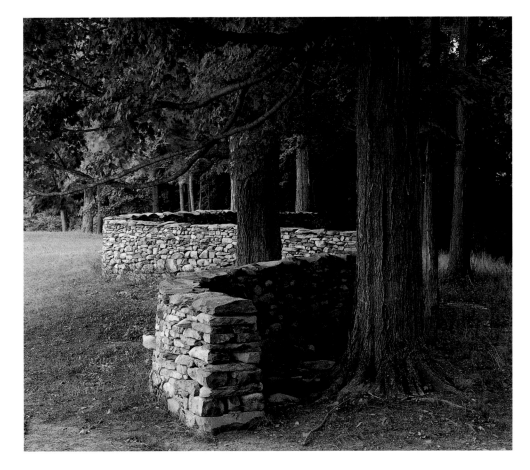

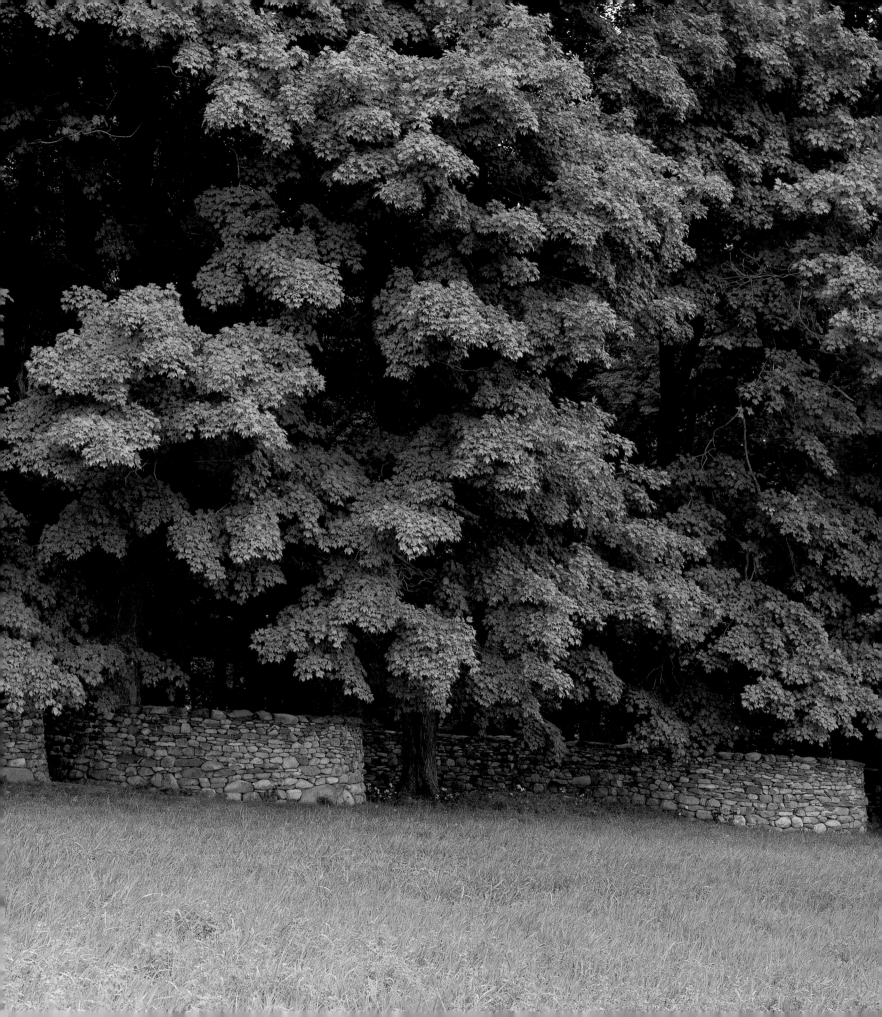

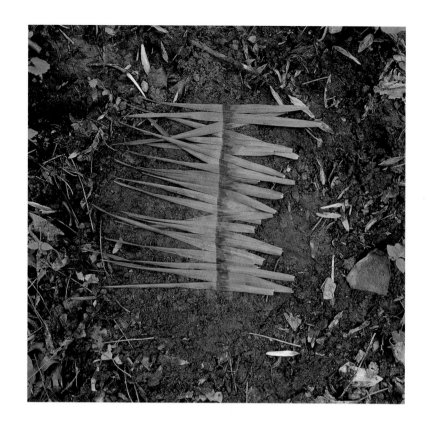

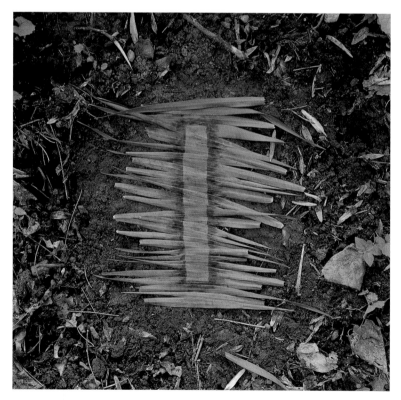

Blades of grass
gently scraped and bruised
with thumbnail

STORM KING ART CENTER
26 MAY 1999

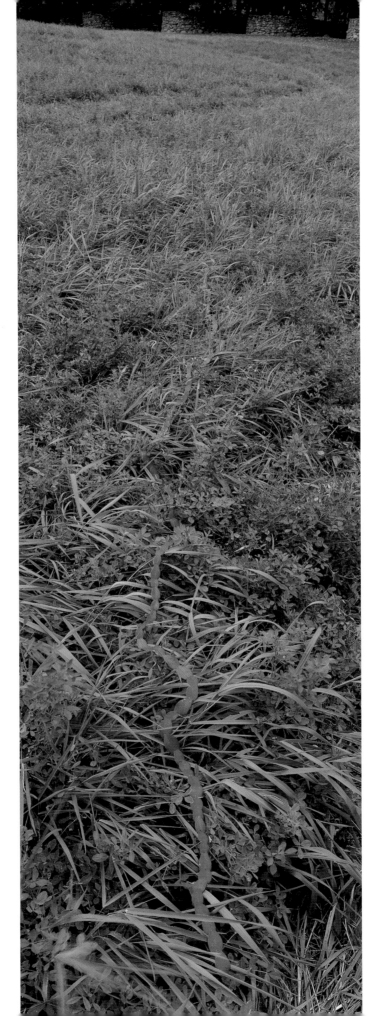

Leaves from spindle-tree
each leaf stitched to the next
to make a line
laid on grass

STORM KING ART CENTER
16 OCTOBER 1998

Overleaf
Sumach leaves
up early
still dark
cold hands
each leaf stitched to another
to make a line
held to willow with stalks
finished just as the sun rose
calm
returned the following day
windy
line broken

STORM KING ART CENTER
17-18 OCTOBER 1998

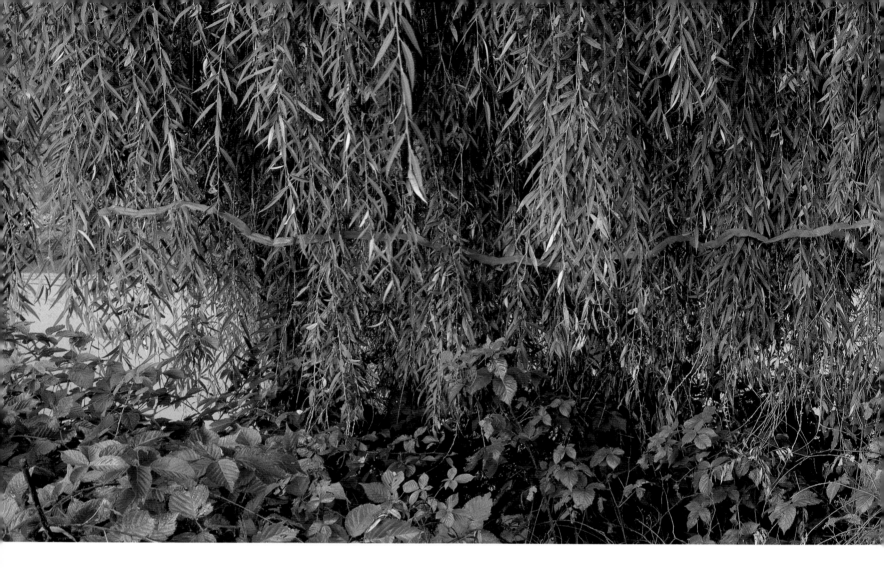

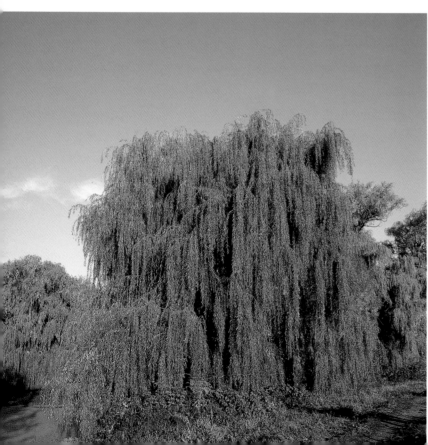

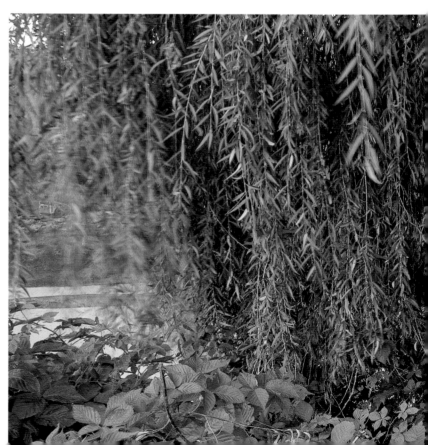

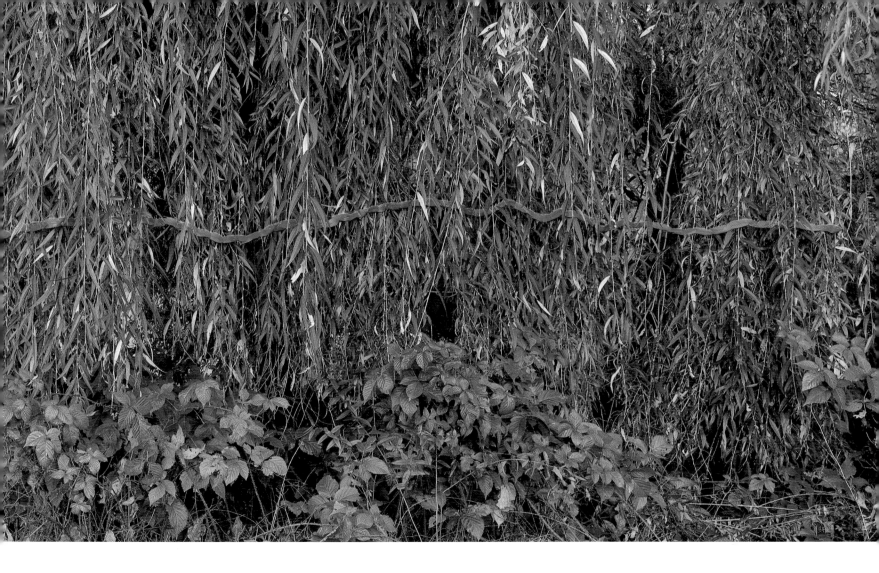
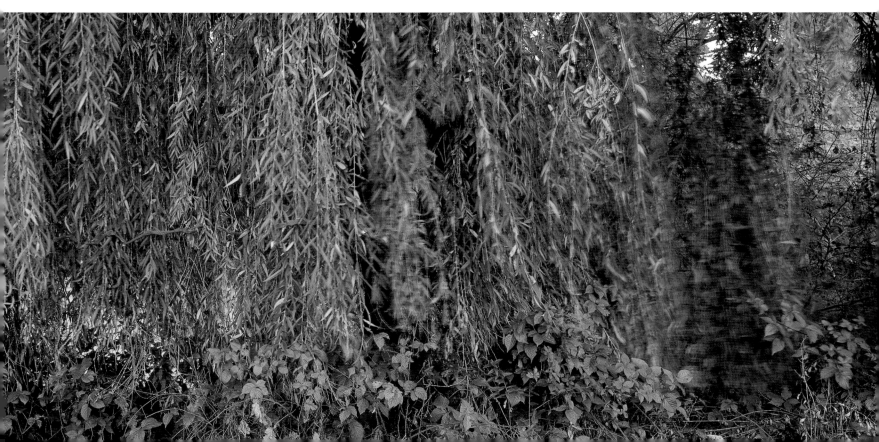

After the wall had reached the lake, I was talking to Bill Rutherford, the landscape architect for Storm King, and remarked that it might be interesting to take it up the other side and over the hill. It was said only half seriously, but Bill immediately said that this would fit in well with his own plans for the area on top of the hill, where there was a quarry which needed to be walled off from the public. By that afternoon, it was pretty much agreed that the wall should continue. It had its own momentum. Although it no longer related precisely to an existing wall, its origin in the old had propelled it into the new.

There are no trees in the field across the lake for the wall to respond to, and so it is straight. The wall in the trees wove because of the trees, the wall on the field is straight because of the field. Both are lines that talk about the places in which they are drawn.

The final destination of this wall was not known in the beginning. I enjoy a sculpture that has this sense of discovery and journey about it. Not knowing the final form or line at the beginning added richness to its making.

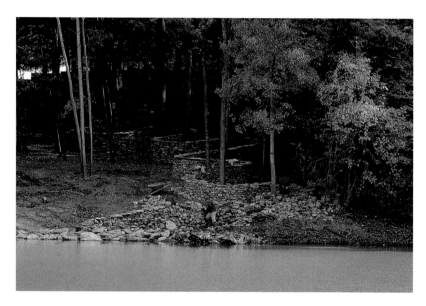

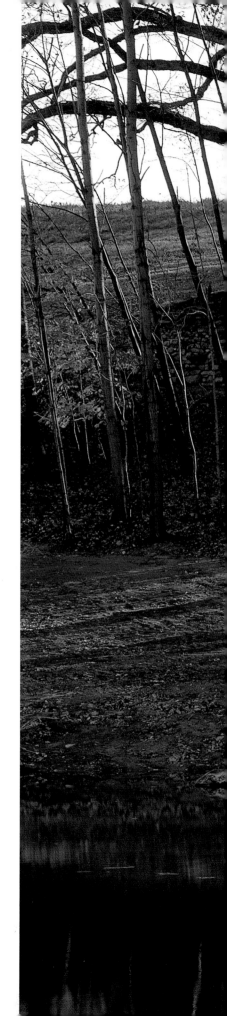

Above: Realigning the wall end where it descends into the water after the decision to allow the wall to continue its journey on the western side of the lake.

Below: Work begins on the western section.

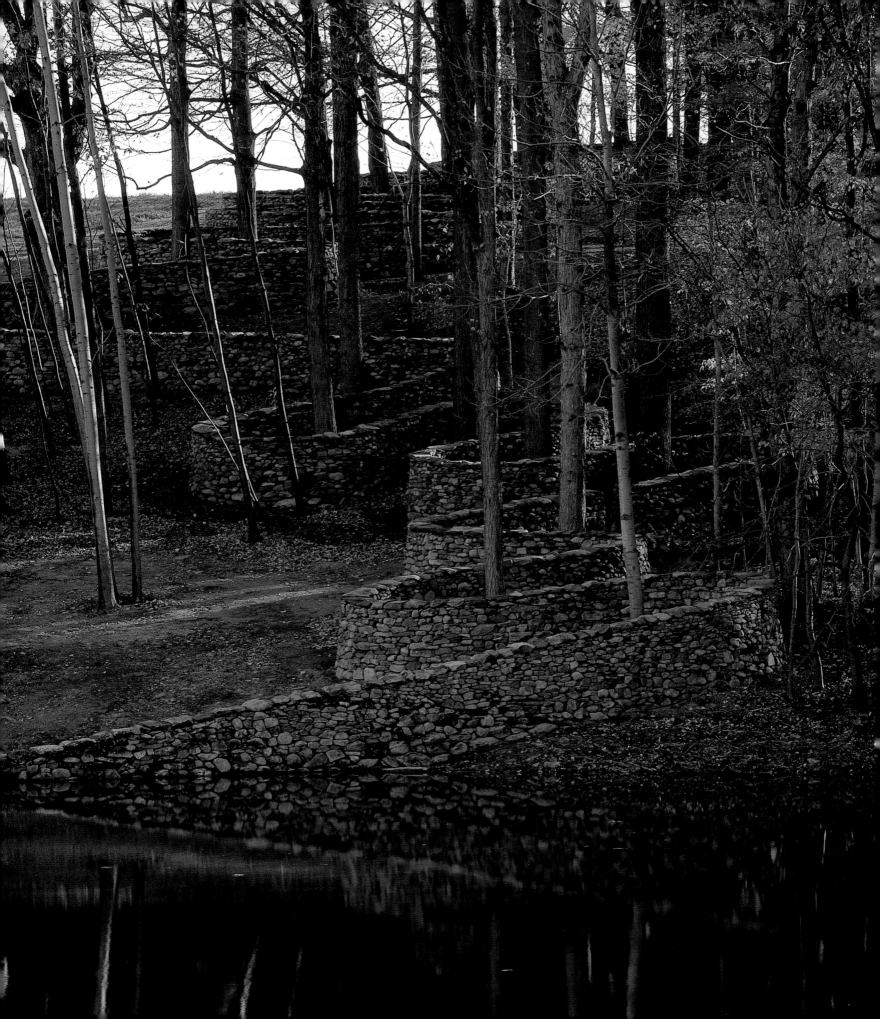

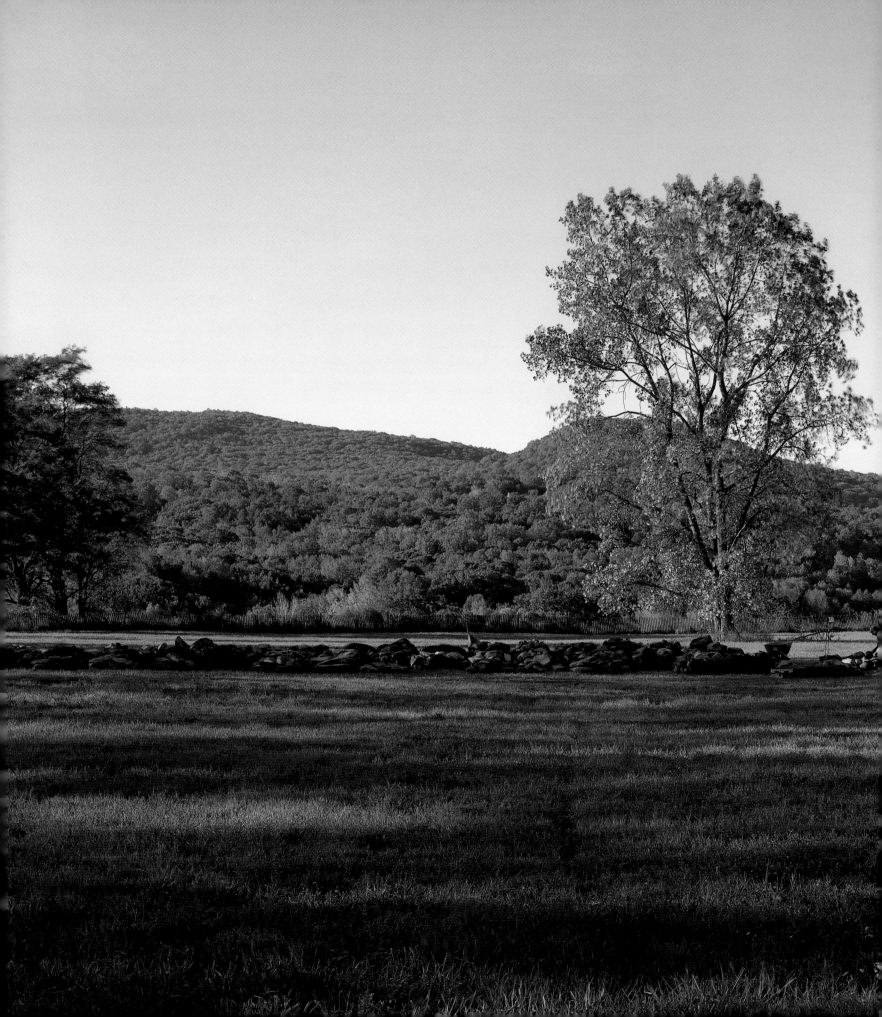

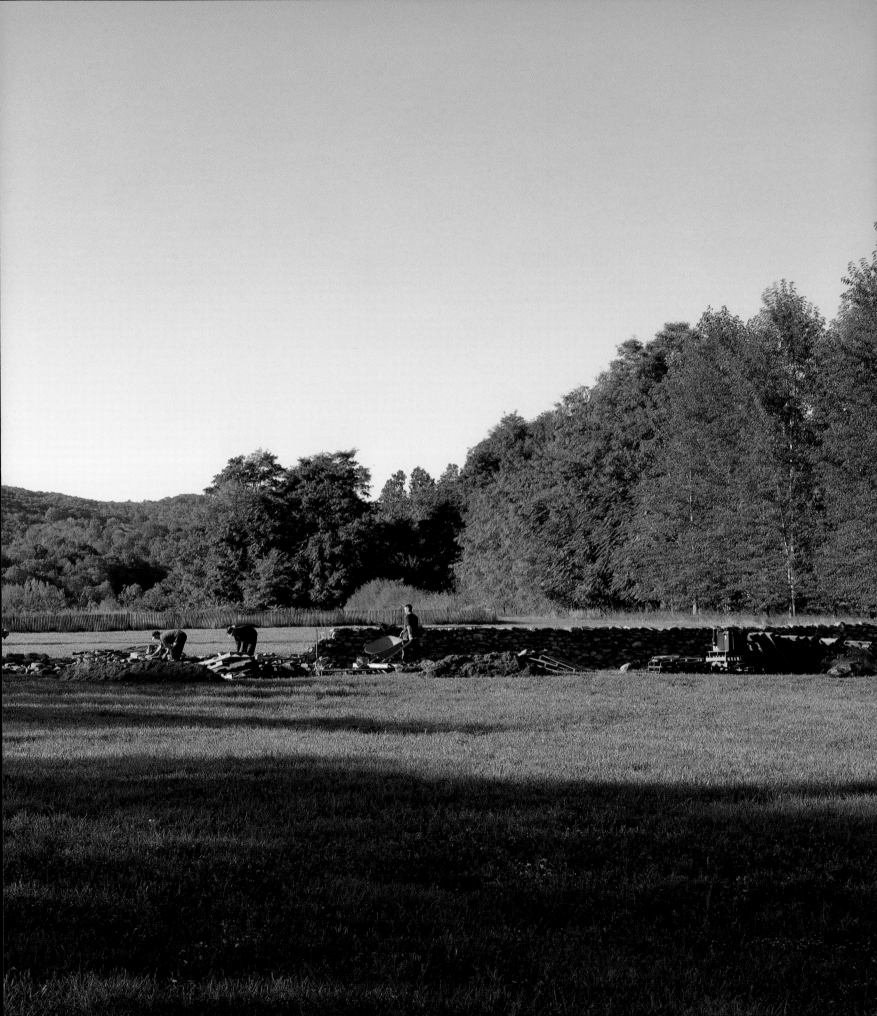

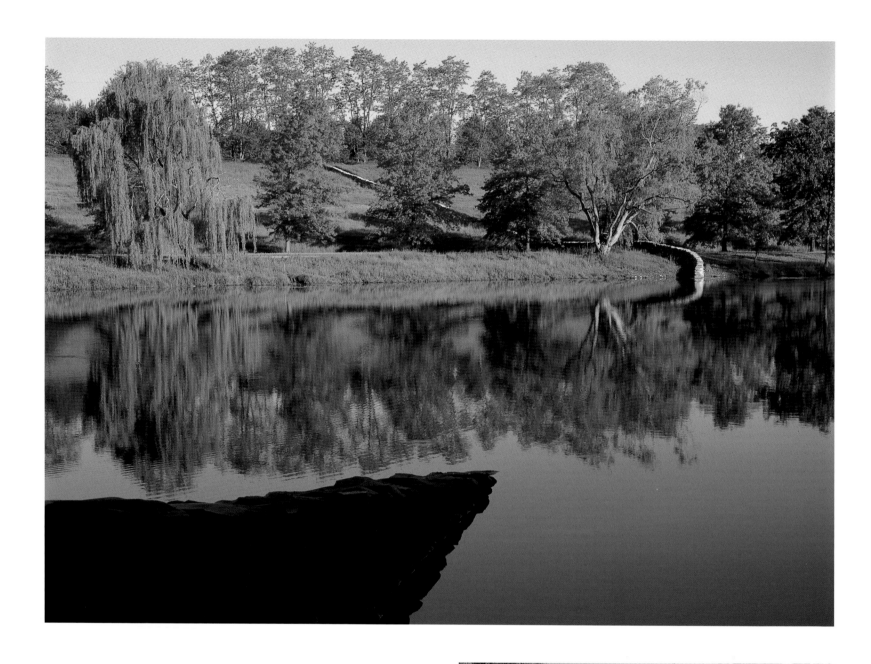

Western section of the wall.

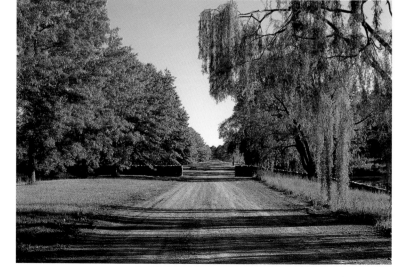

Previous page: Part of the western section under construction.

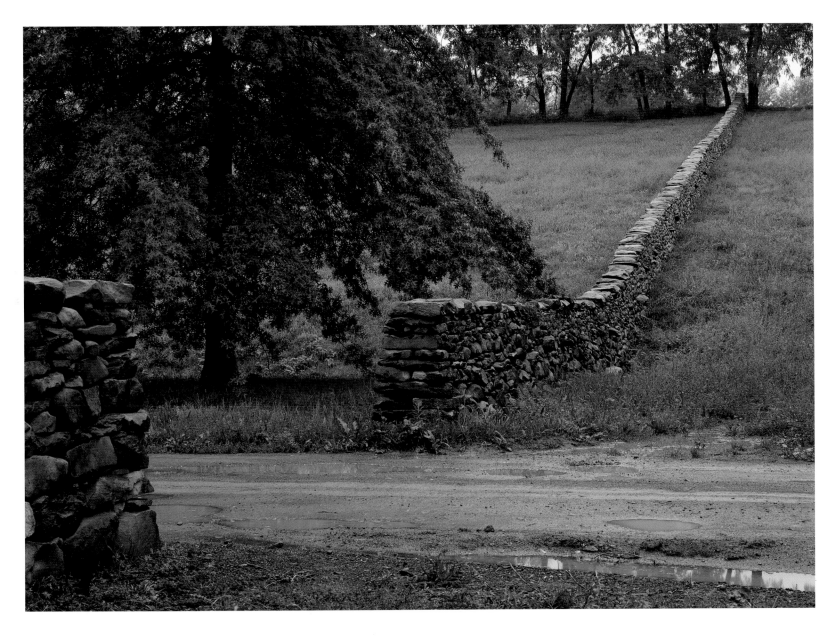

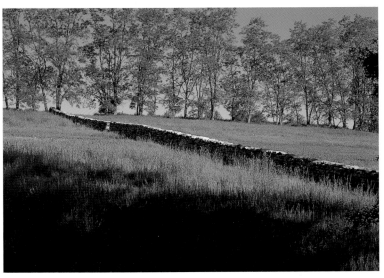

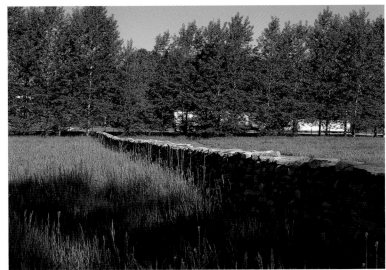

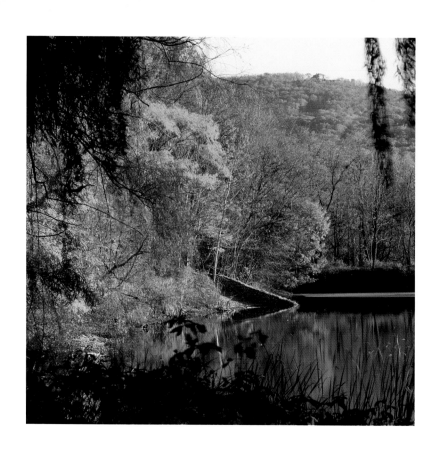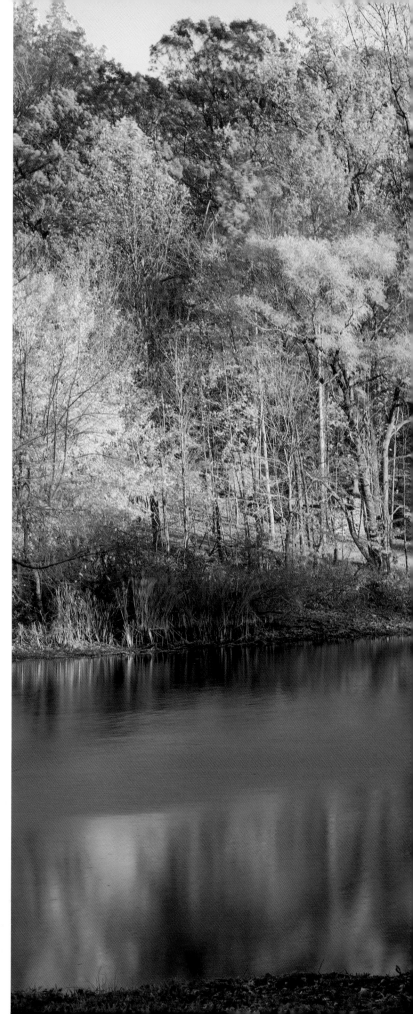

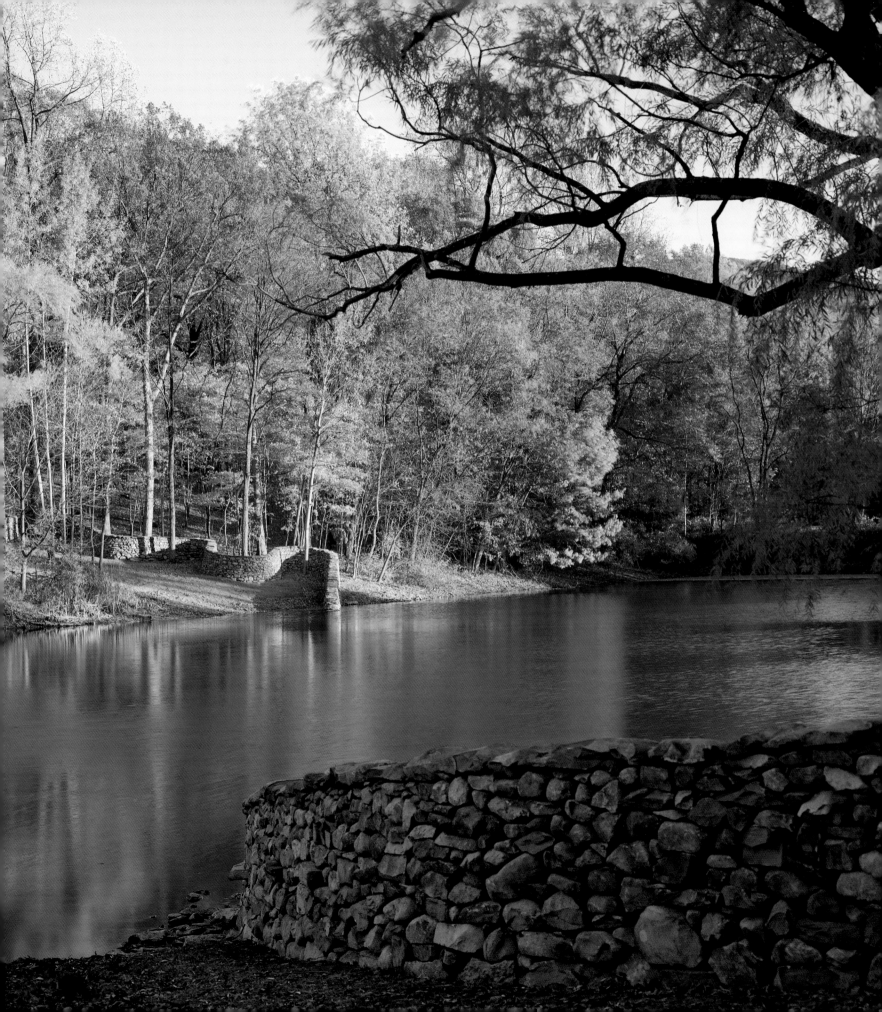

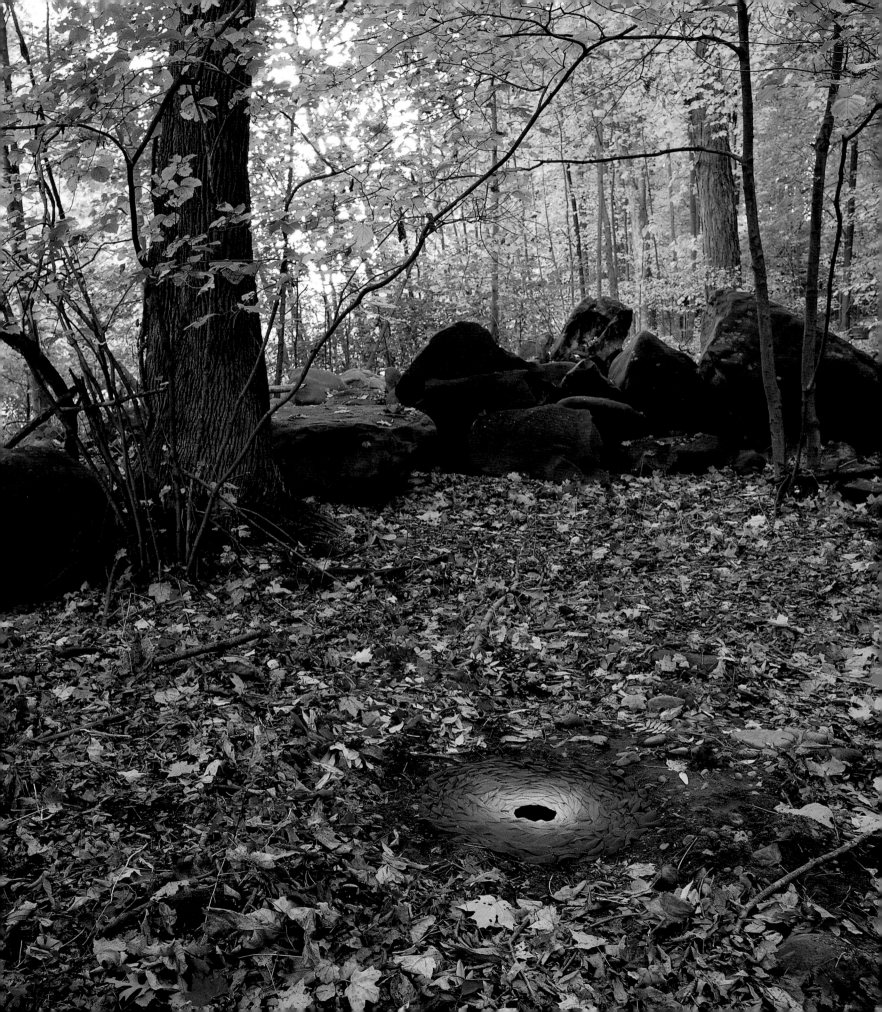

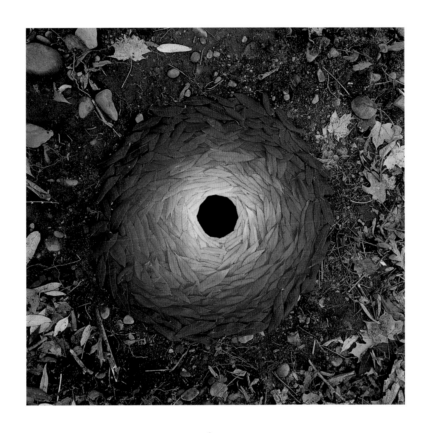

Sumach leaves
laid around a hole

STORM KING ART CENTER
18 OCTOBER 1998

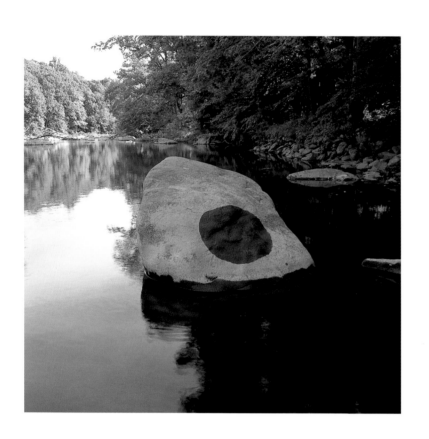 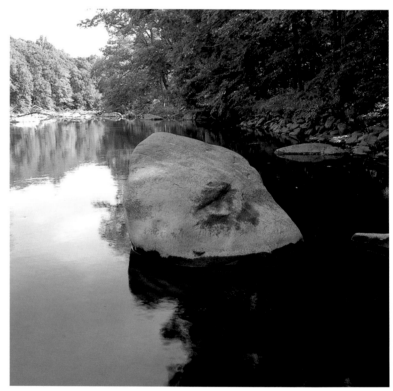

Damp and dry patches

STORM KING ART CENTER

SEPTEMBER & OCTOBER 1997

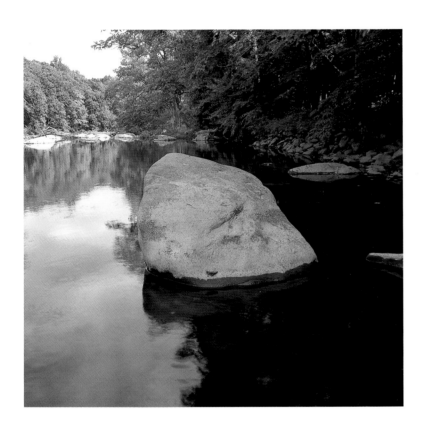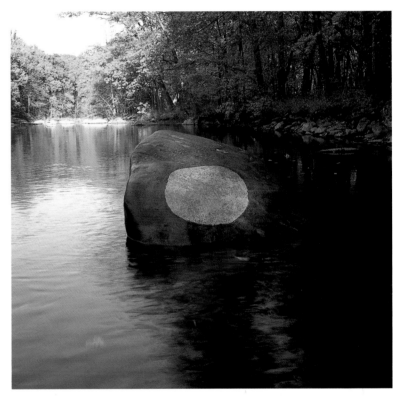

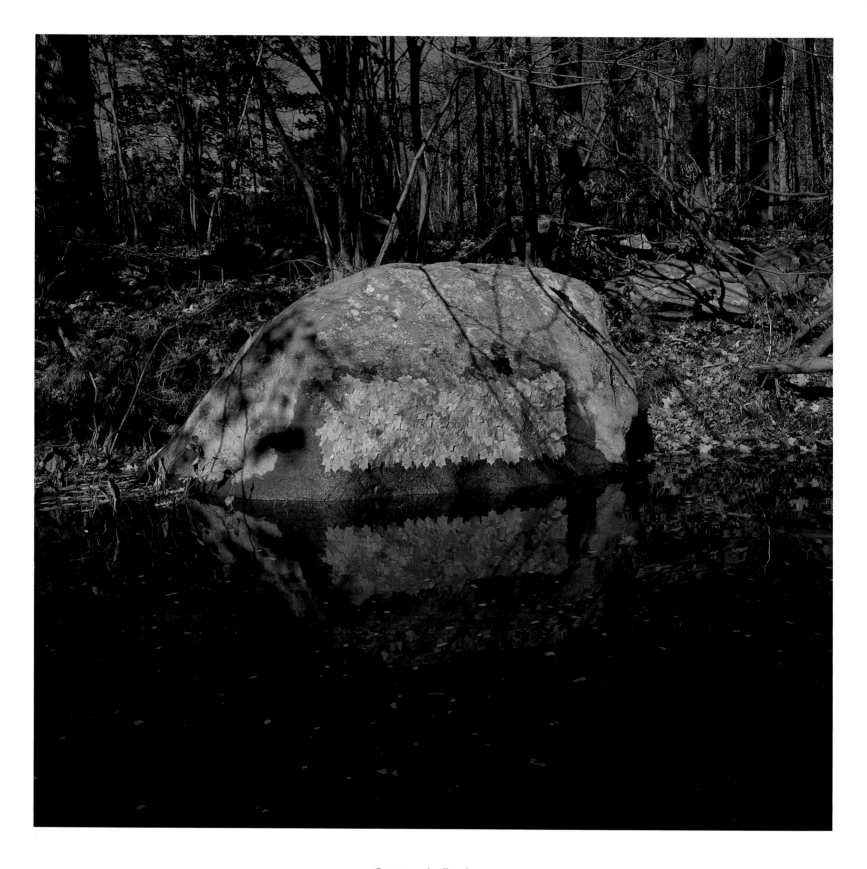

Orange and yellow leaves

held to rock with water

made for the morning sun

STORM KING ART CENTER

30 & 31 OCTOBER 1997

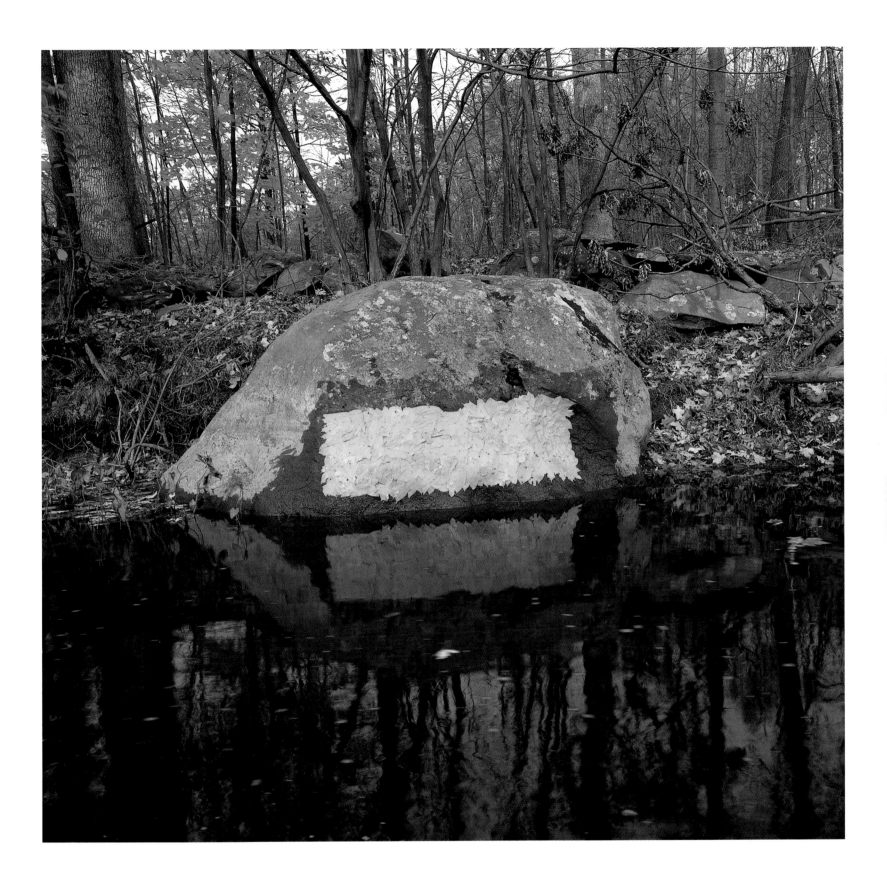

America is a country that has been greatly changed by the displacement and passage of people. Although these changes have in the past been responsible for removing so much richness from the land, they have also, over time, given a different richness back to it. The darker side of a landscape's past is often part of its beauty. It is like standing on the site of a battlefield where trees, grass and flowers now grow. I feel this tension and energy in many of the places that I work in, especially where there are walls. Walls can be harsh. In Britain, during the time of the Enclosures in the nineteenth century, many people were forced off the land where their families had lived and worked for generations. They had little choice but to emigrate.

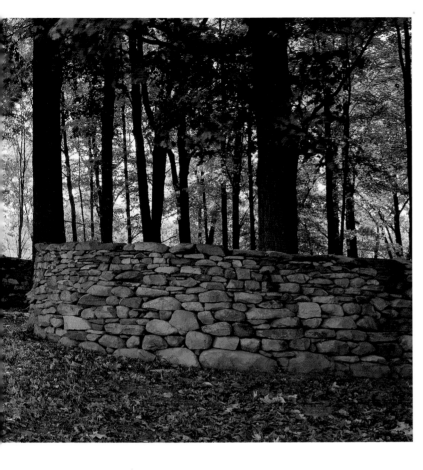

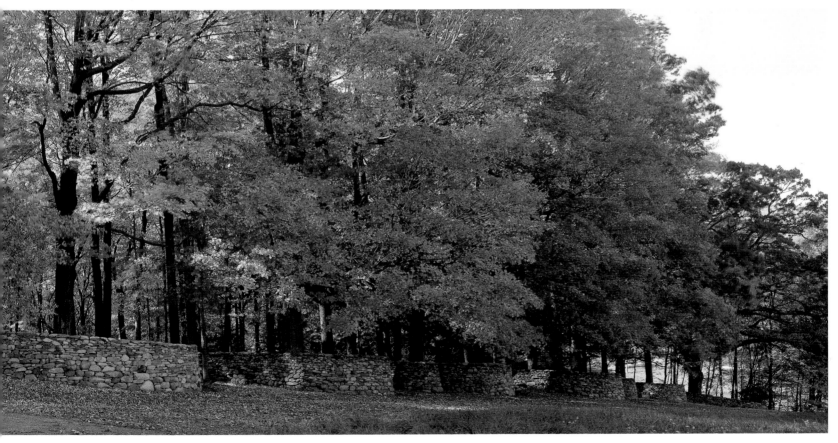

The height and construction of my walls are usually dictated by existing walls in the surrounding area, but in a place where most of them are derelict, it was difficult to know how high the new one should be. The changes in height along the Storm King wall are evidence of my indecision. Of course I could have gone back and made the wall a uniform height, but I feel that this uncertainty is part of the work. By chance, the wall is at its highest where the trees grow closest together, which gives a feeling of the wall being compressed and forced even higher. I also like the more intimate space and dialogue between tree and wall created by the additional height.

When the wallers saw the stone, they were keen to put on a top layer of stones, echoing the wall that was made in Grizedale, a Cumbrian top that is typical of many walls in England. I made part of the Storm King wall with a top like this to see how it looked. People's reactions were instructive in helping me decide what to do. The top stones provoked comment: people found them interesting and liked the Cumbrian style. This was the opposite of what I wanted. For people to notice anything unusual about the wall's construction runs the risk of those elements being perceived as embellishments. It was already too late to take out the 'throughs' (long stones that, as the name suggests, go right through the wall and stick out on either side), which had been attracting too much attention. In Britain, top stones and throughs would be noticeable by their absence, but in America the reverse is the case. So I removed the Cumbrian top and replaced it with something flatter, less interesting and less noticeable.

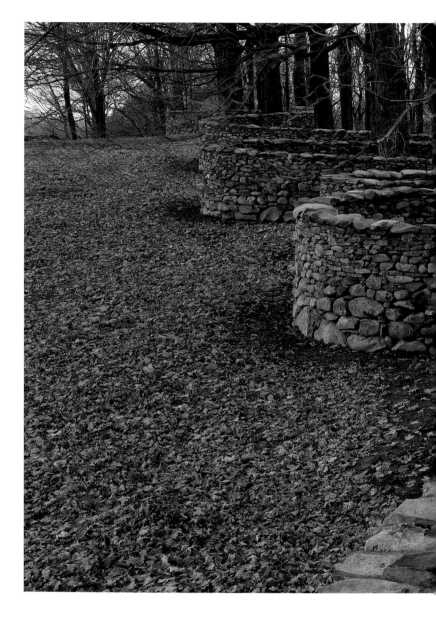

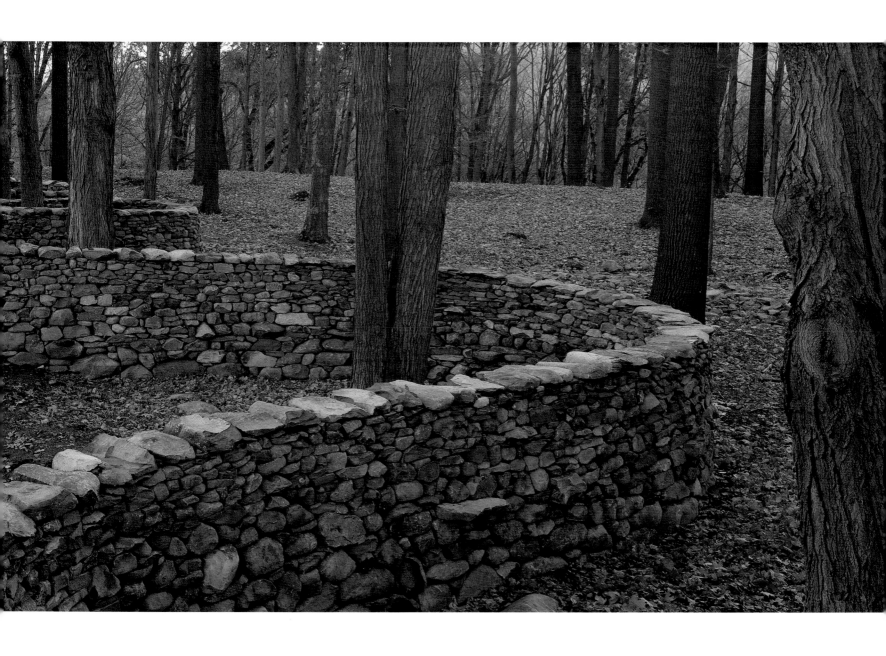

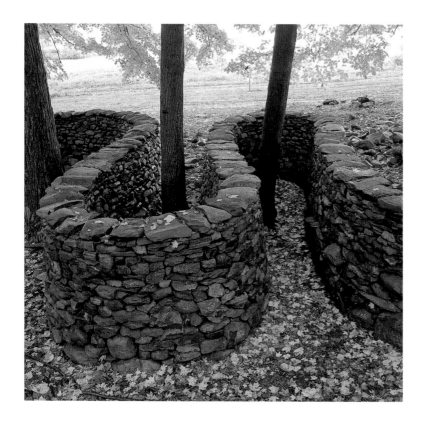

At Storm King, there is a tension between the trees and the wall. It will not remain as it is now. As the trees grow bigger, they will threaten the wall. The most compressed part of the wall, where the trees grow closest together, is the heart of the sculpture, and the place where there is most tension. Inevitably, the trees will cause the wall's collapse, either, eventually, because of the sheer size of their trunks or because they are uprooted and crash on to it.

The wall is not an object to be preserved in the traditional sense of art conservation. It is at the beginning of its life. What kind of life it has will depend on what happens to it. There are many possibilities.

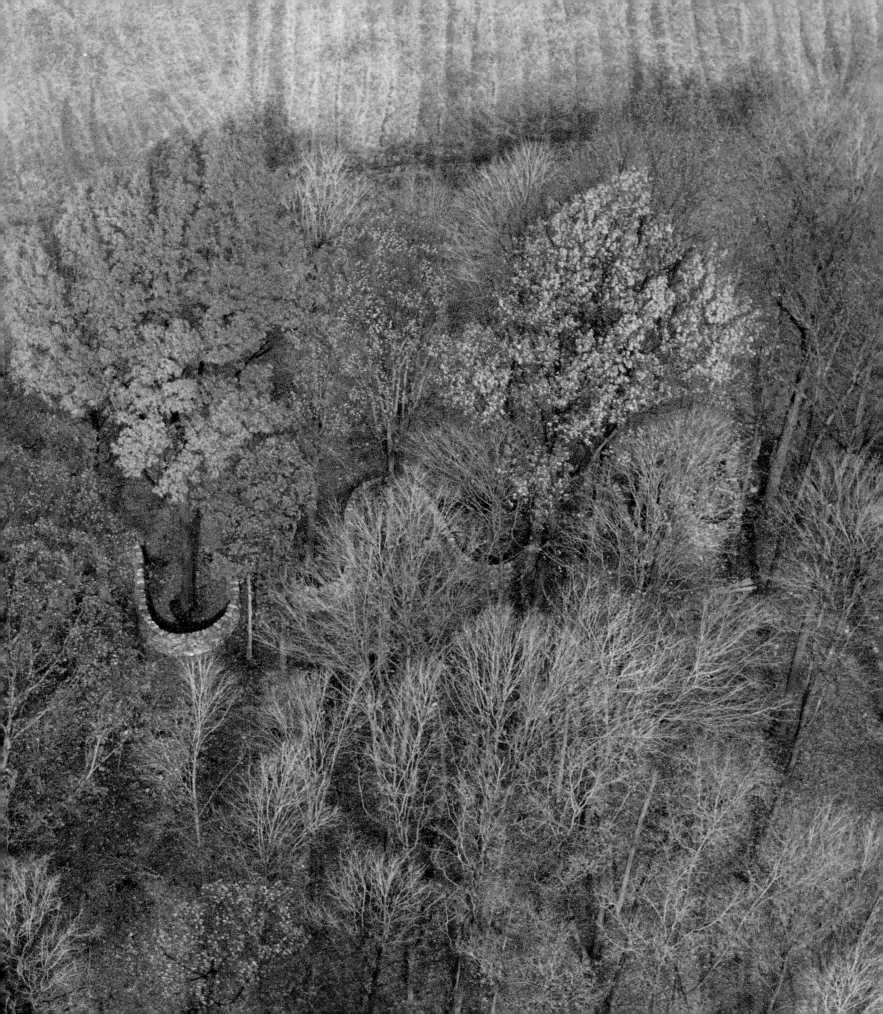

One of Seven Spires

GRIZEDALE FOREST, CUMBRIA

1984

Opposite

Collapsed spire

GRIZEDALE FOREST, CUMBRIA

1997

The dry-stone construction of the wall makes it vulnerable to the unpredictable and at times destructive forces of growth, time and people. Fragility and risk give the wall its energy. For it to retain this energy I must accept that the work has an uncertain future – even at the extreme of the wall being allowed to decay and trees left where they fall.

It is now fifteen years since I made my first 'permanent' work, Seven Spires, in Grizedale Forest. I remember the discussions at the time about the ten- to fifteen-year life expectancy of the sculpture. The Grizedale stone wall was made of a more durable material, but the area around it has changed so much that it cannot now be considered the sculpture it was when it was first made. The gradual thinning out of surrounding trees has represented the least interesting period of the wall's life, placing the sculpture in a state of limbo – not yet changed enough to become something else. When all the trees have been felled and the land returned to pasture, the original wall might perhaps be rebuilt straight once again, leaving my wall traceable only by faint, curved humps in the grass.

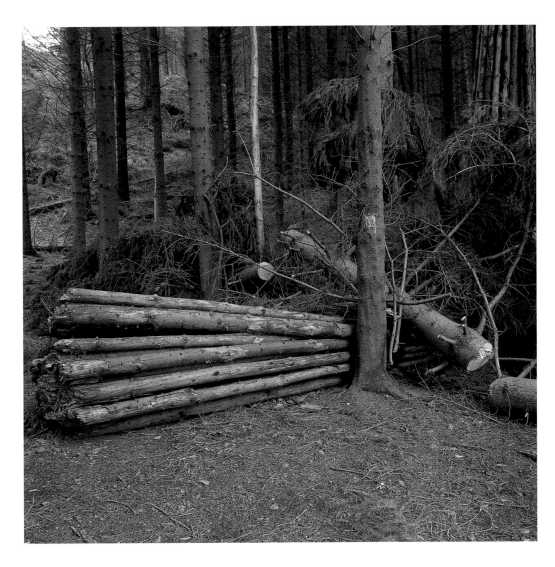

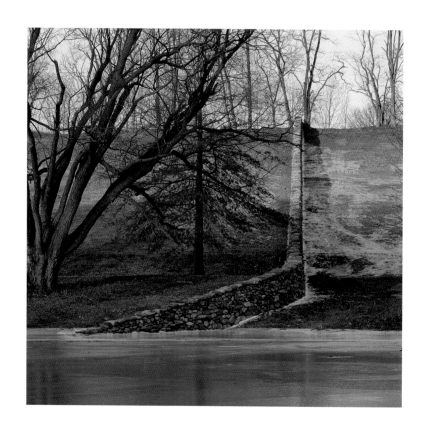

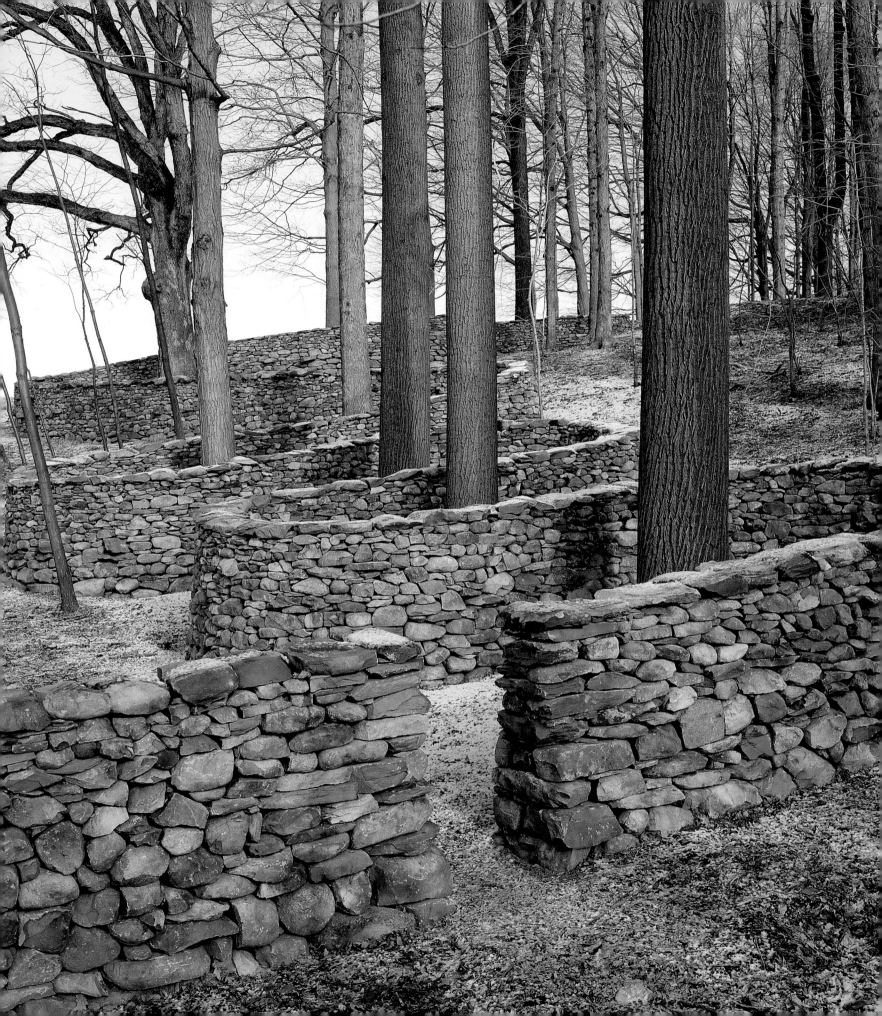

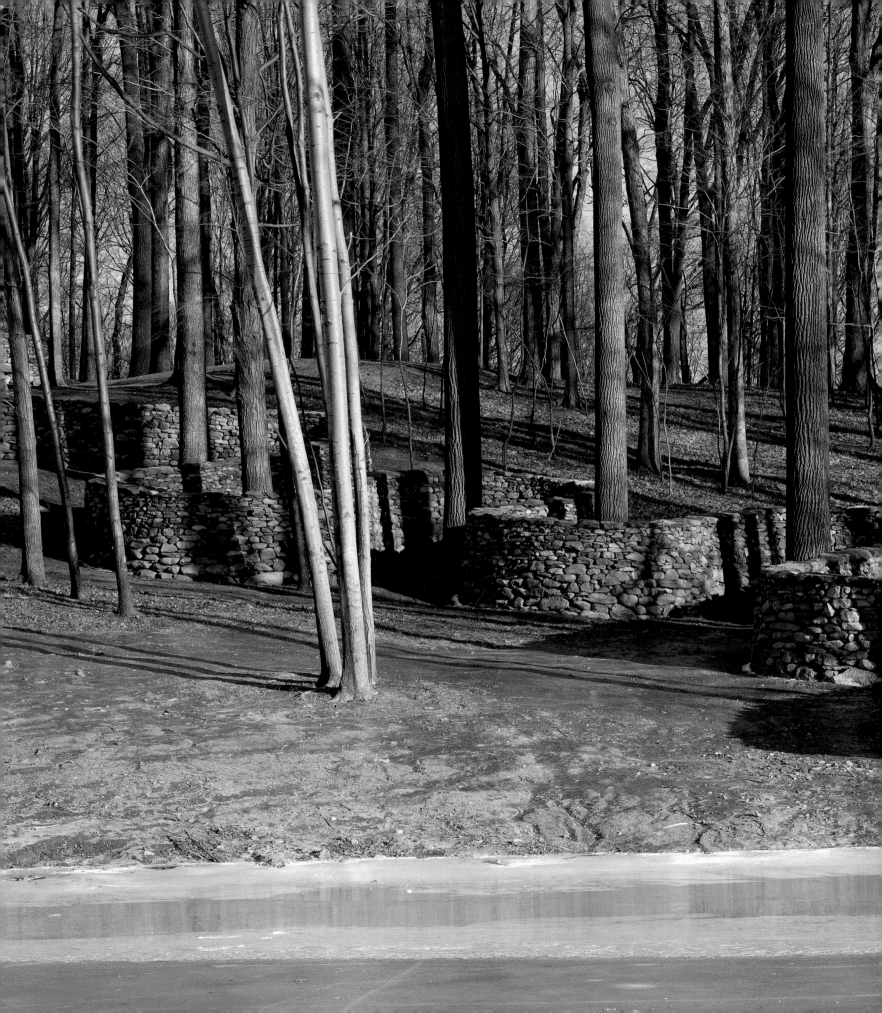

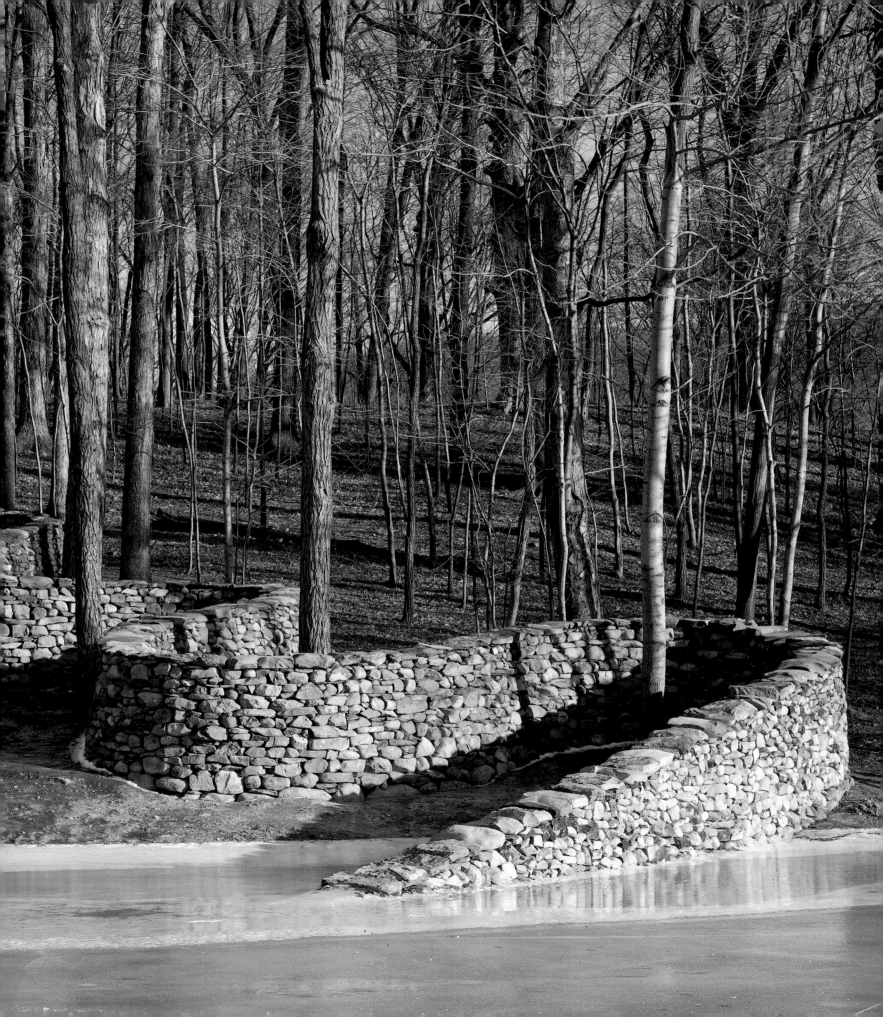

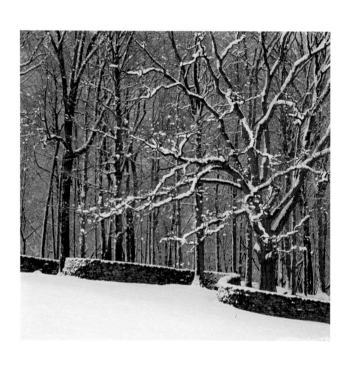
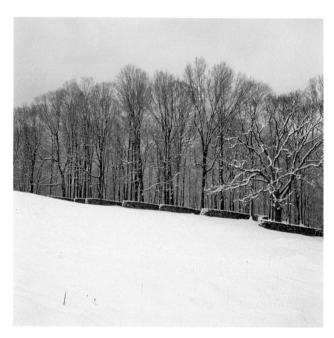
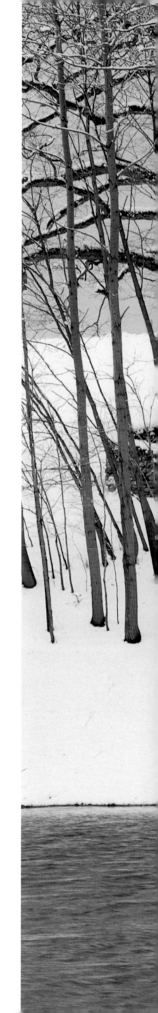

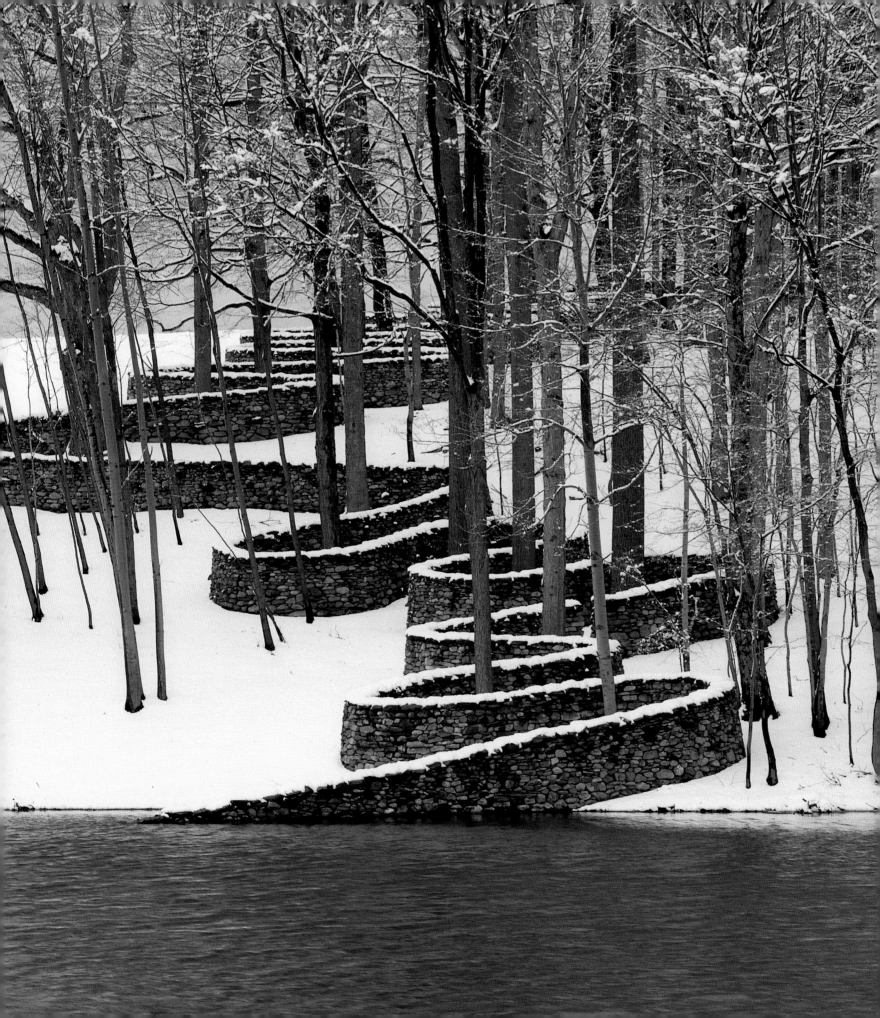

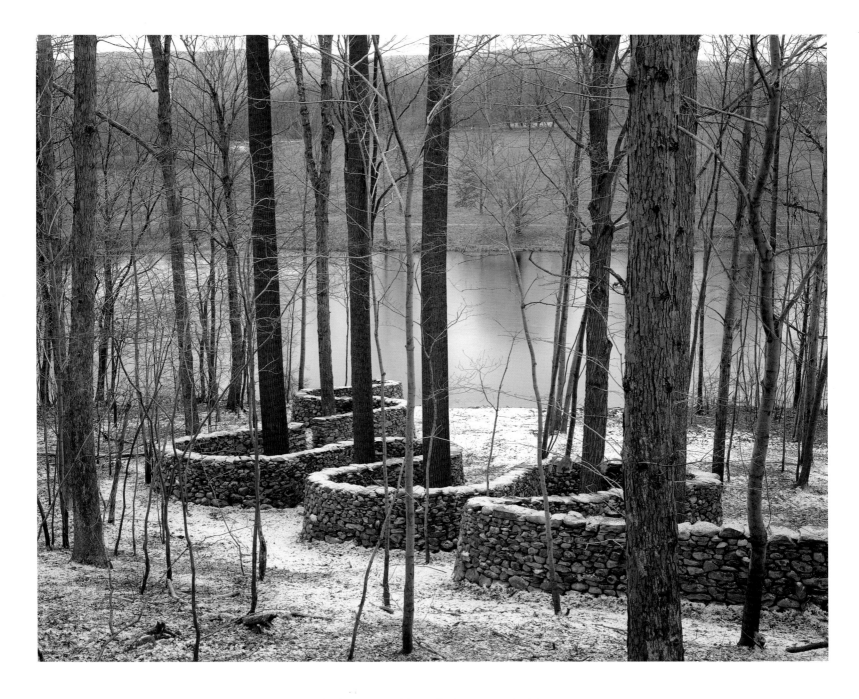

The first version of the wall's descent into the lake.

WINTER 1997

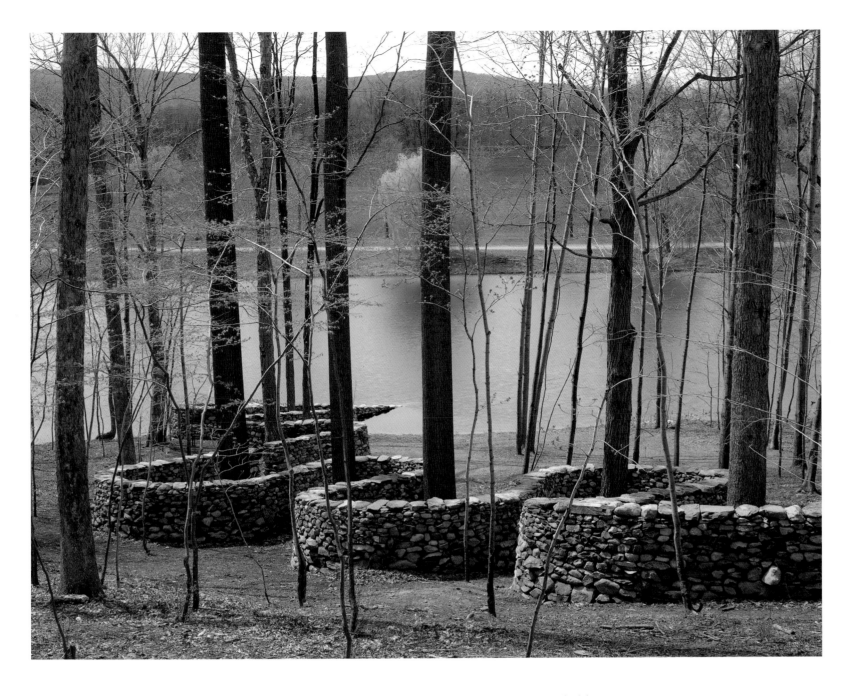

The final version, modified to align with the western section across the lake.

SPRING 1999

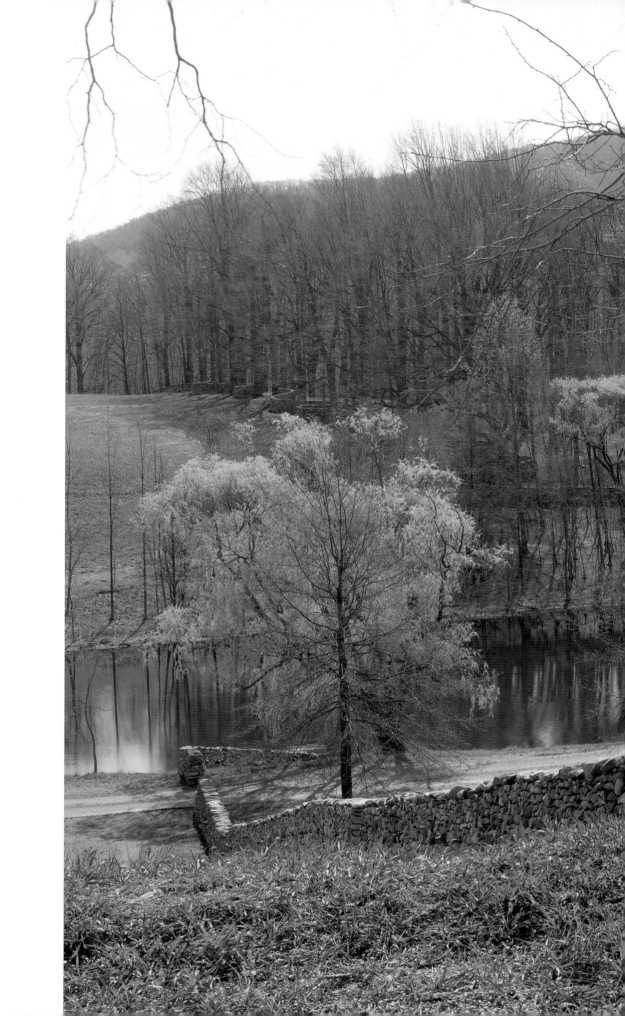

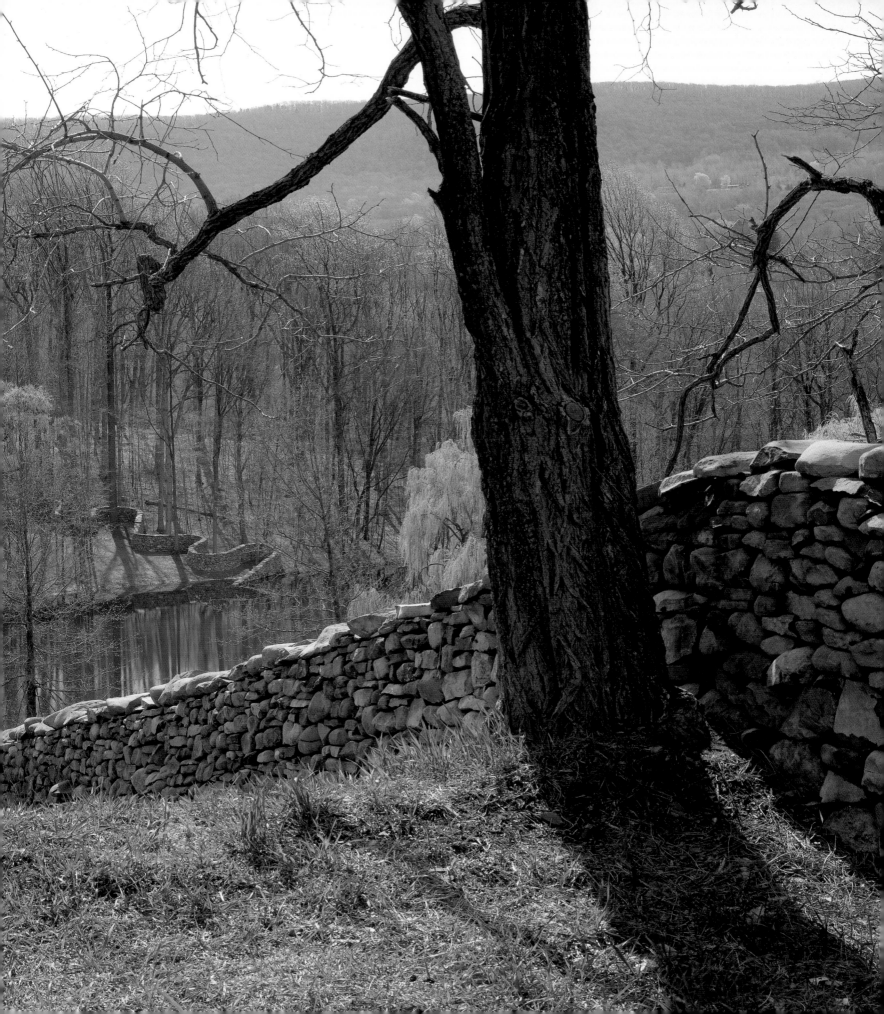

Throughout the wall's construction, my role was to make regular visits to assess its progress. At the same time, I made ephemeral works in the river that runs through Storm King. There was an important link between the river of water and the river of stone that the wall was becoming. Working simultaneously at the scale of a leaf and the scale of the wall gives me a deeper understanding of the energy that brings these forms into being.

I also undertook a commission near to my first American wall sculpture in Westchester County using stones from a small creek (or beck) to make a series of arches to follow the creek, some straddling it, others stepping in and out of the water, a final arch springing out of an adjoining wall – another expression of the connections that I feel exist between stone and water.

Eleven creek arches

Assisted by Nigel Metcalfe and Patrick Marold

WESTCHESTER COUNTY, NEW YORK

FALL 1997

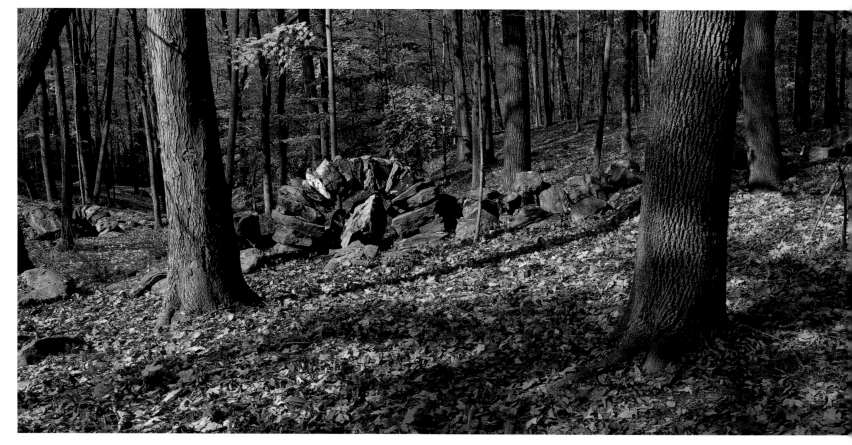

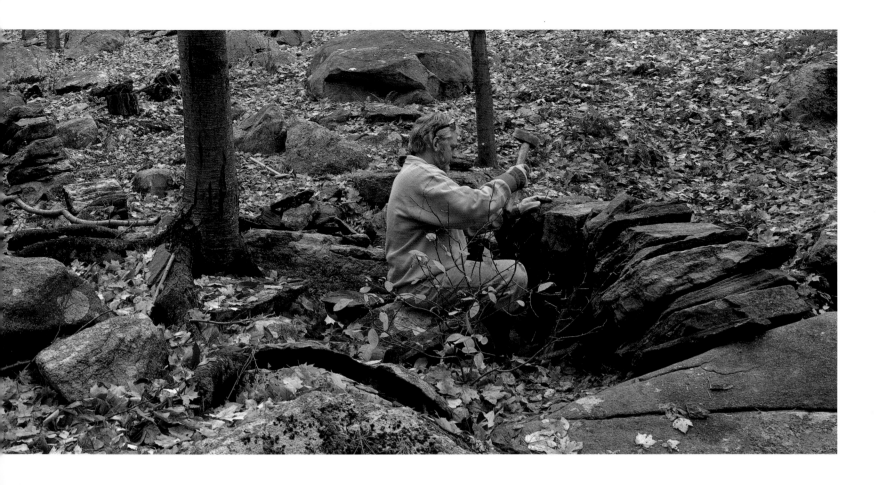

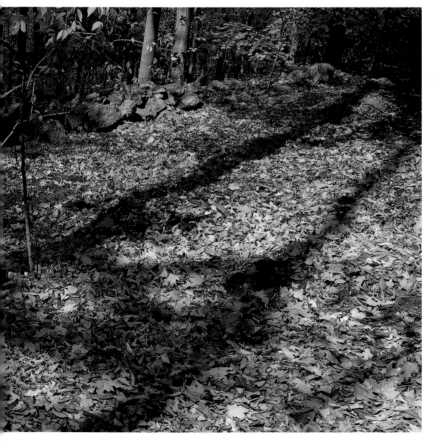

In Norman Nicholson's collection of poems, *Sea to the West*, 'Wall' follows 'Beck'. That he talks of constructed stone and geological stone almost in the same breath strikes a chord with me. Like Nicholson, I feel a powerful sense of flow and movement in stone – whether it has been shifted by geological forces or by people. The Storm King wall, although made of stone, is not static, but weaves between the trees with an energy and movement that I could not achieve with a straight wall. It has a quality of passing through – like the previous wall which came and went with the people who farmed there.

BECK

Not the beck only,
Not just the water –
The stones flow also,
Slow
As continental drift,
As the growth of coral,
As the climb
Of a stalagmite.
Motionless to the eye,
Wide cataracts of rock
Pour off the fellside,
Throw up a spume
Of gravel and scree
To eddy and sink
In the blink of a lifetime.
The water abrades,
Erodes; dissolves
Limestones and chlorides;
Organizes its haulage –
Every drop loaded
With a millionth of a
 milligramme of fell.
The falling water
Hangs steady as stone;
But the solid rock
Is a whirlpool of commotion,
As the fluid strata
Crest the curl of time,
And top-heavy boulders

Tip over headlong,
An inch in a thousand years.
A Niagara of chock-stones,
Bucketing from the crags,
Spouts down the gullies.
Slate and sandstone
Flake and deliquesce,
And in a grey
Alluvial sweat
Ingleborough and Helvellyn
Waste daily away.
The pith of the pikes
Oozes to the marshes,
Slides along the sykes,
Trickles through ditch and dub,
Enters the endless
Chain of water,
The pull of earth's centre –
An irresistible momentum,
Never to be reversed,
Never to be halted,
Till the tallest fell
Runs level with the lowland,
And scree lies flat as shingle,
And every valley is exalted,
Every mountain and hill
Flows slow.

Norman Nicholson

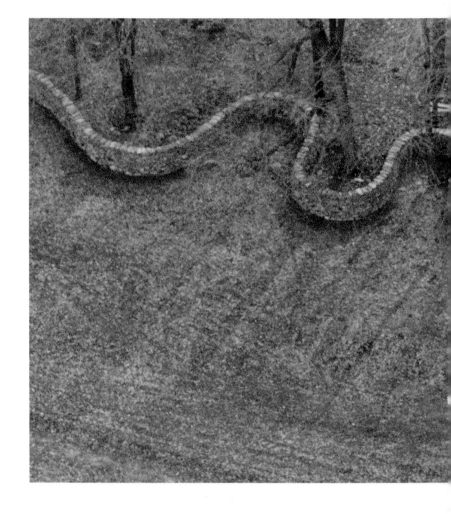

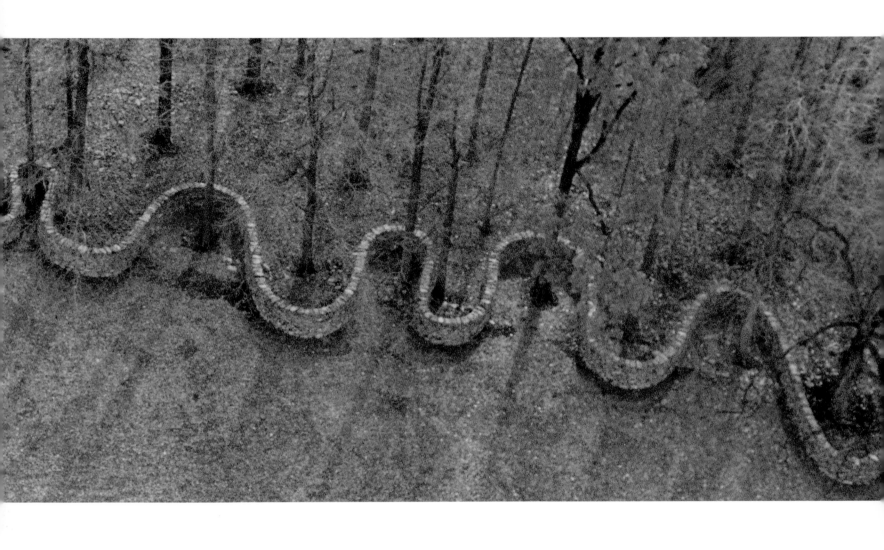

THE WALLERS

STEVE ALLEN

Born 23rd August 1960 in Kendal, Cumbria, Steve Allen first learnt walling on the family farm near Tebay 11 miles away, working with slate. Now living in the village of Tebay, he works principally as a waller, but still helps out with seasonal tasks on his father's farm. He has at one time or another won first prize at most regional British walling competitions (which involve using unfamiliar stone and competing against local wallers), and has won the Grand Prix of the Drystone Walling Association of Great Britain five times. He became a Master Craftsman in 1990. A book on walling in contemporary Britain by David Griffiths entitled *It's in There Somewhere* (1999) is, in part, an account based on Steve Allen's working experience.

MAX NOWELL

Born 29th May 1957 and brought up in Berkshire, Max Nowell took a degree in agriculture and economics at the University of Reading. In 1979, he moved to south-west Scotland and for nine years managed a small farm. He learnt the skills of walling, or dyking, as it is called in this part of the world, working on local farms, predominantly with whinstone. He now lives in the Dumfriesshire parish of Irongray and divides his time between dyking, masonry work and managing a smallholding.

GORDON WILTON

Born 27th February 1947 at Parsley Hay in Derbyshire, Gordon Wilton has lived in nearby Biggin for most of his life. He learnt his trade on the local limestone walls, first mending walls as a boy on his father's smallholding, then on the farm where he worked for twenty years after leaving school. He broadened his knowledge by entering (and often taking first prize at) a variety of regional walling competitions, each involving the use of a different type of stone and varying techniques, and became a Master Craftsman in 1994. He has twice been Grand Prix champion of the Drystone Walling Association of Great Britain.

JASON WILTON

Born 12th May 1976, Jason Wilton started working with his father, Gordon, when he was 16. Having been the Derbyshire junior drystone walling champion at the age of 12 and Amateur National Champion at 17, he is clearly following his father's lead.

ABOUT STORM KING

Storm King Art Center, situated 55 miles north of Manhattan, is a museum that celebrates the relationship between sculpture and nature. Five hundred acres of landscaped lawns, fields and woodlands provide the site for a substantial collection of postwar sculpture by internationally renowned artists, including Magdalena Abakanowicz, Siah Armajani, Alice Aycock, Alexander Calder, Mark di Suvero, Andy Goldsworthy, Louise Nevelson, Isamu Noguchi, Richard Serra and David Smith. At Storm King, the exhibition space is defined by sky and land and surrounded by the dramatic profiles of the Hudson Highlands. Ever-varying weather conditions and changing light ensure that no two visits are the same.

To reach Storm King Art Center from New York City
Go over the George Washington Bridge and keep right to exit on to the Palisades Interstate Parkway, which you follow to its end, past the point where the road briefly widens to three lanes. At the end of Palisades Parkway is a traffic circle, where you take Route 9W north (signposted to West Point and Newburgh). Follow this winding road for 11 miles, and just after an overpass crosses the road, take the Cornwall exit and turn left on to Route 107. Go downhill to a traffic light where you turn right on to Route 32. Turn left immediately after the bridge on to Orrs Mill Road and after half a mile turn left on to Old Pleasant Hill Road. The entrance to Storm King Art Center is on your left.

Opening times
1st April to 15th November: sculpture park open 11.00 am to 5.30 pm daily (and until 8.00pm on Saturdays in June, July and August.)
Indoor galleries open mid May to mid November.

Storm King Art Center
P.O. Box 2808
Old Pleasant Hill Road
Mountainville
New York 10953-0280
Telephone: 845-534-3115; fax: 845-534-4457

Produced by Jill Hollis and Ian Cameron
Cameron Books, Moffat, Dumfriesshire, Scotland

ISBN 0–8109–4559–2

Published in 2000 by Harry N. Abrams, Incorporated, New York

Printed and bound in Italy by Artegrafica, Verona

 The artist is represented by: Haines Gallery, San Francisco; Michael
Hue-Williams Fine Art, London; Galerie Lelong, New York and Paris,
Galerie S65, Aalst, Belgium

Harry N. Abrams, Inc.
100 Fifth Avenue
New York, N.Y. 10011
www.abramsbooks.com

Endpapers: Three Roadside Boulders (detail), 1996

I would like to thank Peter Stern, Chairman and President of Storm King, David
Collens, Director of Storm King, and landscape architect Bill Rutherford for having
faith in such an ambitious project and for their support, and all the staff at the Art
Center for their help. I am also indebted to Jerry L. Thompson, whose highly
skilled and sensitive photographs have greatly enriched the portrayal of the Storm
King wall.

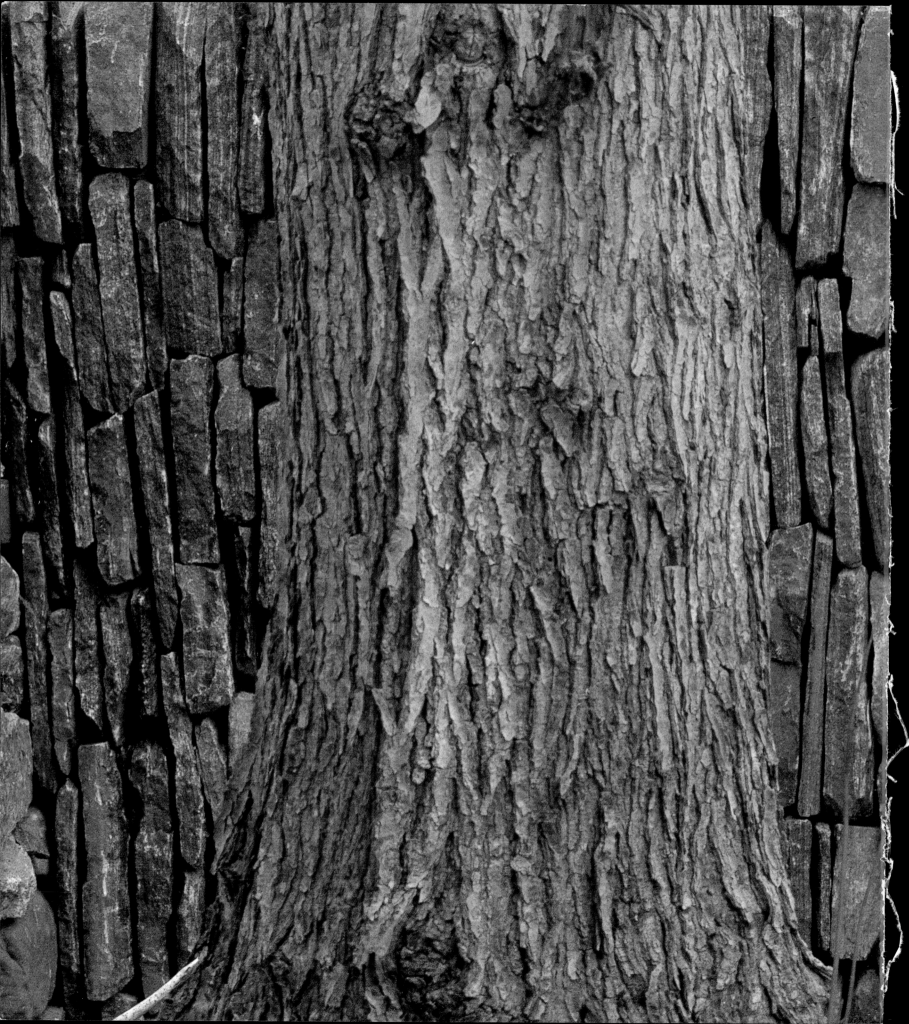